CHICAGO

IMPRESSIONS | PHOTOGRAPHY BY GERALD D. TANG

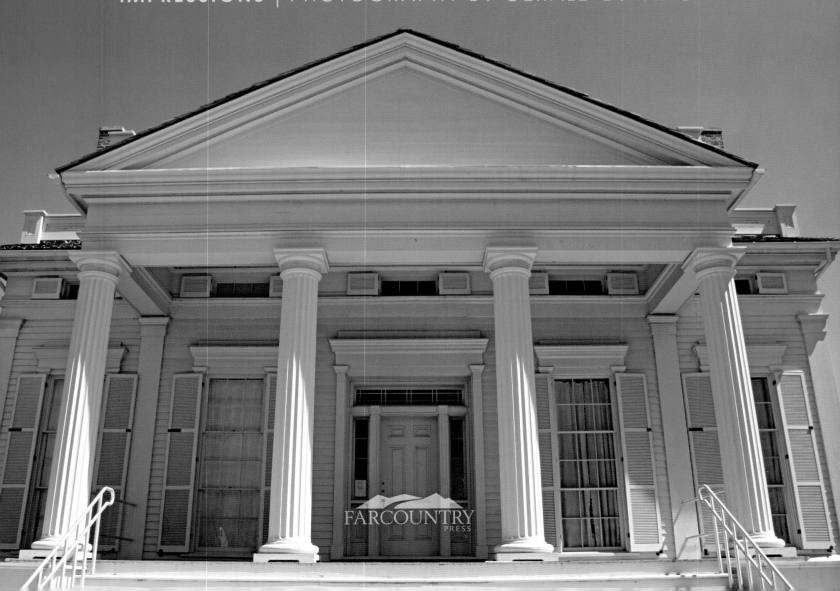

FARCOUNTRY
PRESS

Right: The distinctive skyline of the Windy City rises above Lake Michigan.

Below: This stained-glass dome in the Chicago Cultural Center is one of two spectacular rotundas in the building, which was completed in 1897.

Title page: The solid symmetry of Greek Revival architecture pulls your eye to the Clarke House, one of Chicago's oldest residences. It was built around 1836 and now serves as a museum anchoring the historic Prairie Avenue District.

Cover: Built in 1927, Buckingham Fountain glows in front of a backdrop of fabulous modern architecture. This pleasing contrast of old and new urban design exemplifies Chicago's rich history and vibrant present.

Back cover: A marsh blazing star and the bristly buds of rattlesnake master thrive in the wetlands around Chicago.

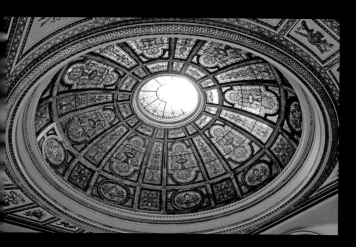

ISBN 10: 1-56037-474-8
ISBN 13: 978-1-56037-474-9

Updated in 2014
© 2007 by Farcountry Press
Photography © 2007 by Gerald D. Tang

For more information about our books, write Farcountry Press, P.O. Box 5630, Helena, MT 59604; call (800) 821-3874; or visit www.farcountrypress.com.

Produced in the United States of America.
Printed in China.

18 17 16 15 14 3 4 5 6 7

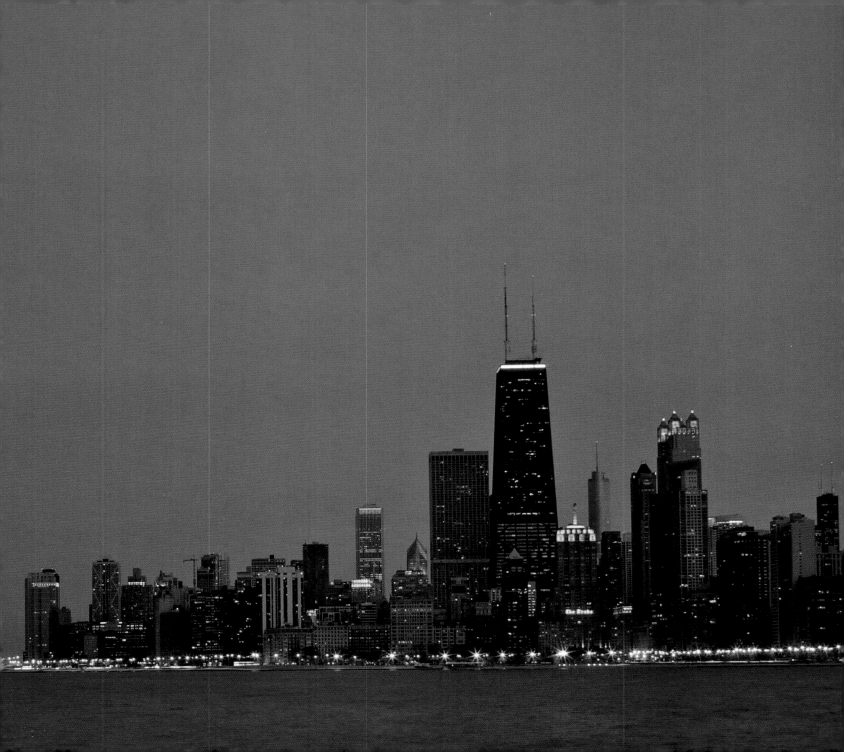

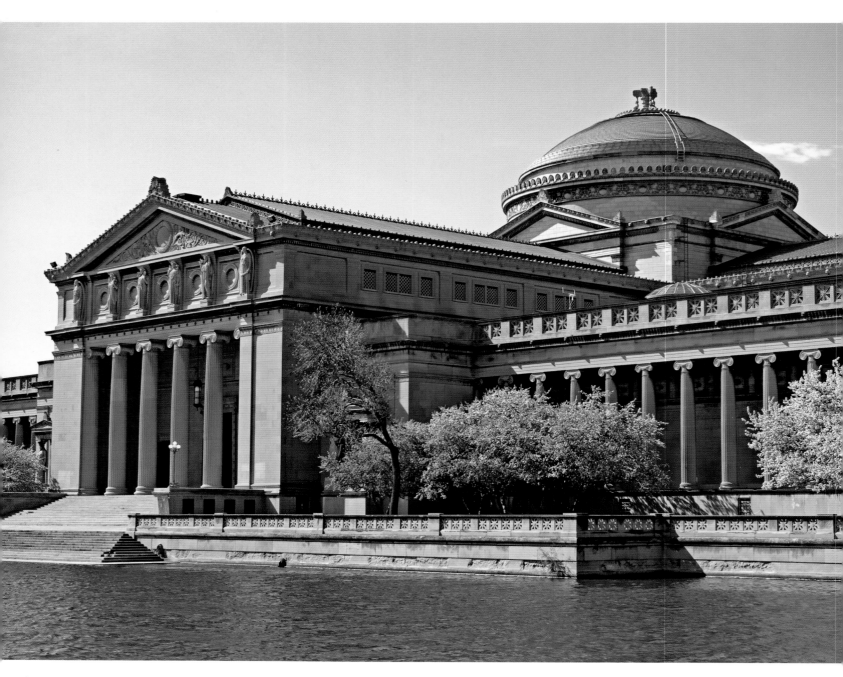

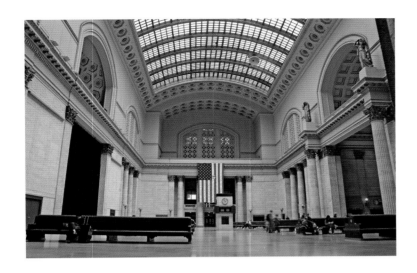

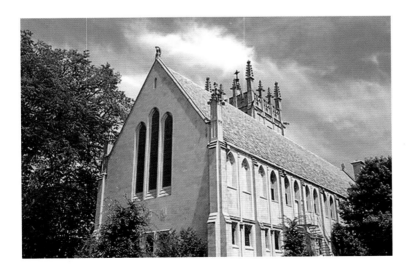

Left, top: The impressive Beaux Arts-style Great Hall in Union Station boasts an arched skylight and extensive balconies.

Left, bottom: The Garrett-Evangelical Theological Seminary is on the campus of Northwestern University in Evanston. This graduate school of theology has connections to the United Methodist Church.

Far left: The Chicago World's Fair of 1893 celebrated the 400th anniversary of Columbus's landing in North America. Originally built as the Palace of Fine Arts to showcase the World's Columbian Exposition, this massive building now houses the Museum of Science and Industry.

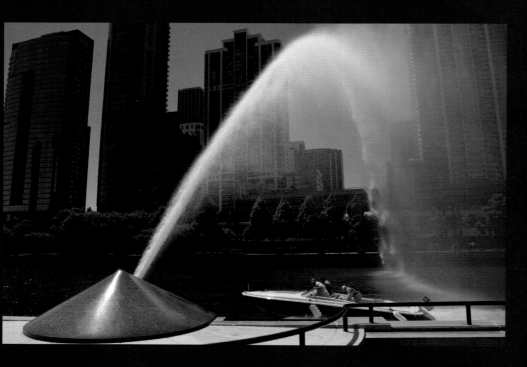

Above: Boaters duck under the water arc of the Nicholas J. Melas Centennial Fountain. The fountain forms its distinctive arc for ten minutes each hour.

Right: Soldier Field was dedicated in 1925 in honor of members of the American military. After a $365 million remodel was completed in 2003, Soldier Field II seats 61,500 for concerts, festivals, and sporting events. The stadium is home to the NFL's Chicago Bears.

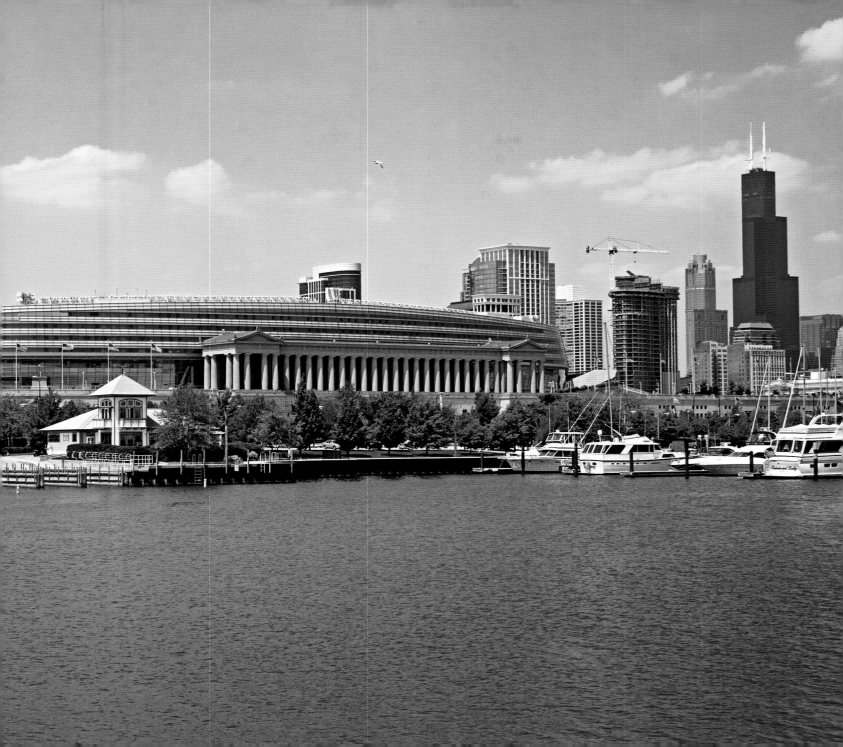

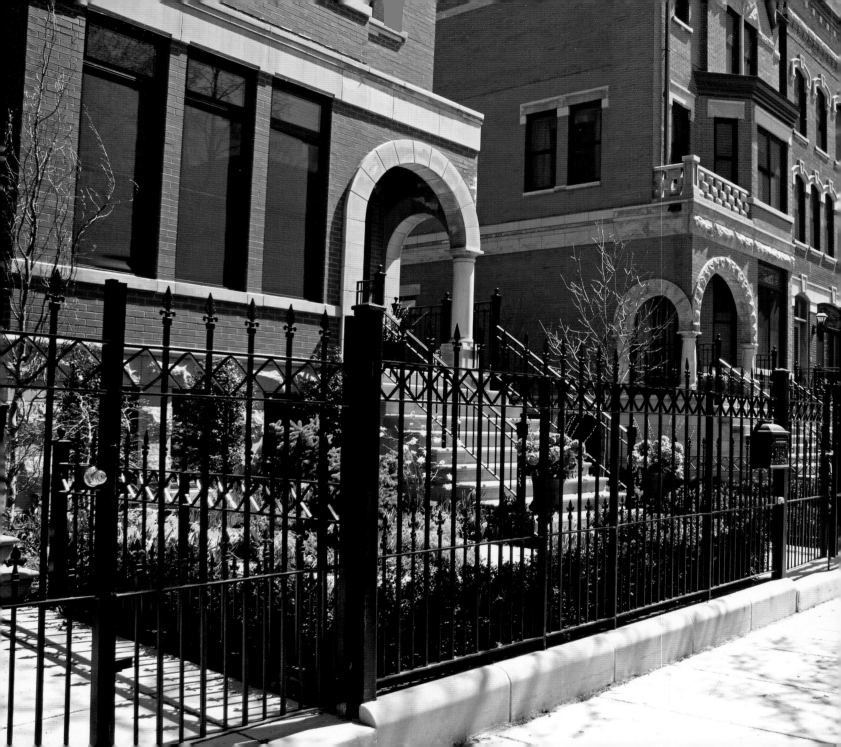

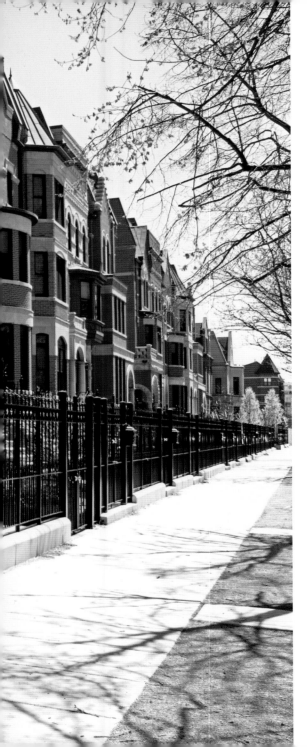

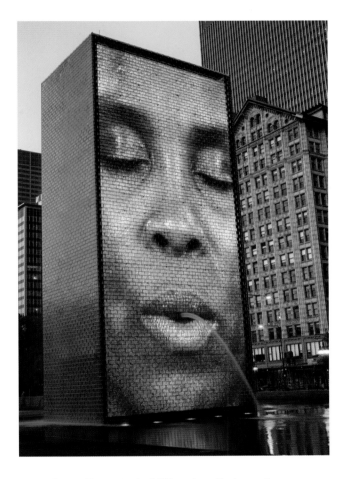

Above: *Crown Fountain*, in Millennium Park, projects composite images made from the faces of 1,000 Chicago citizens.

Left: Chicago's most prestigious residential area in the late nineteenth century boasted superb homes on the 1800 block, now showcased as part of the Prairie Avenue Historic District.

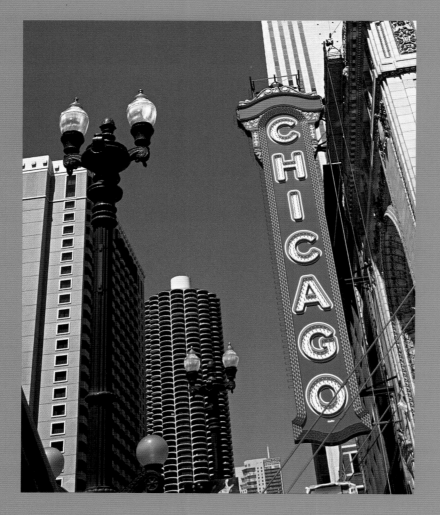

Above: The Chicago Theatre sign is nearly six stories tall. The lavish auditorium seats 3,600.

Right: A tube built above the Illinois Institute of Technology's student center muffles the roar of the commuter train. The train is commonly called the "L" for "elevated" train.

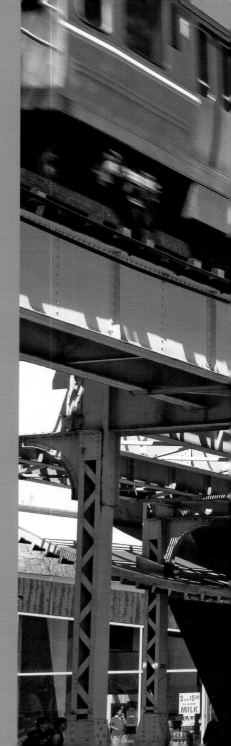

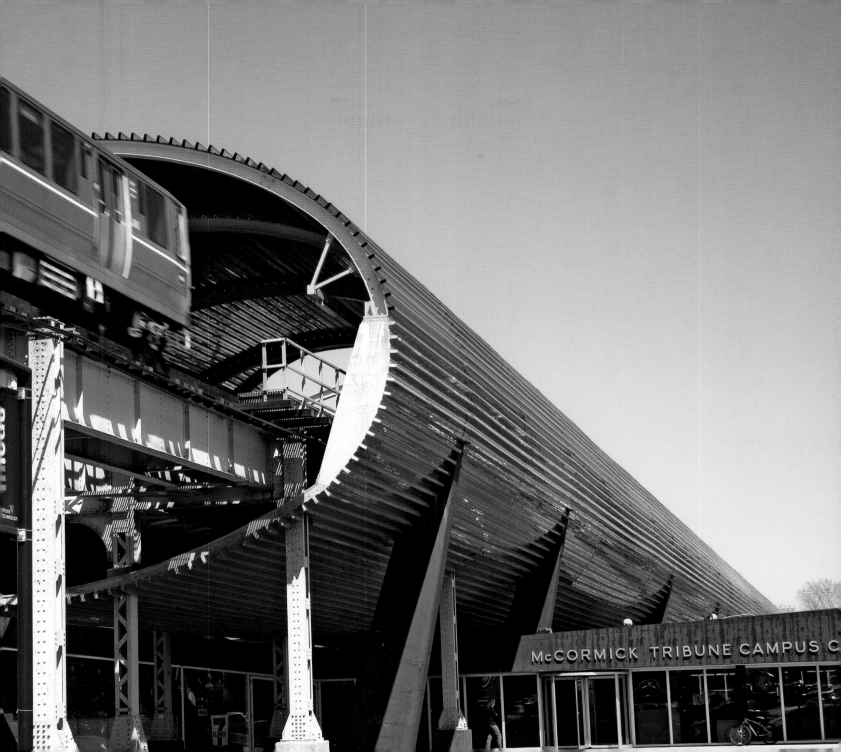

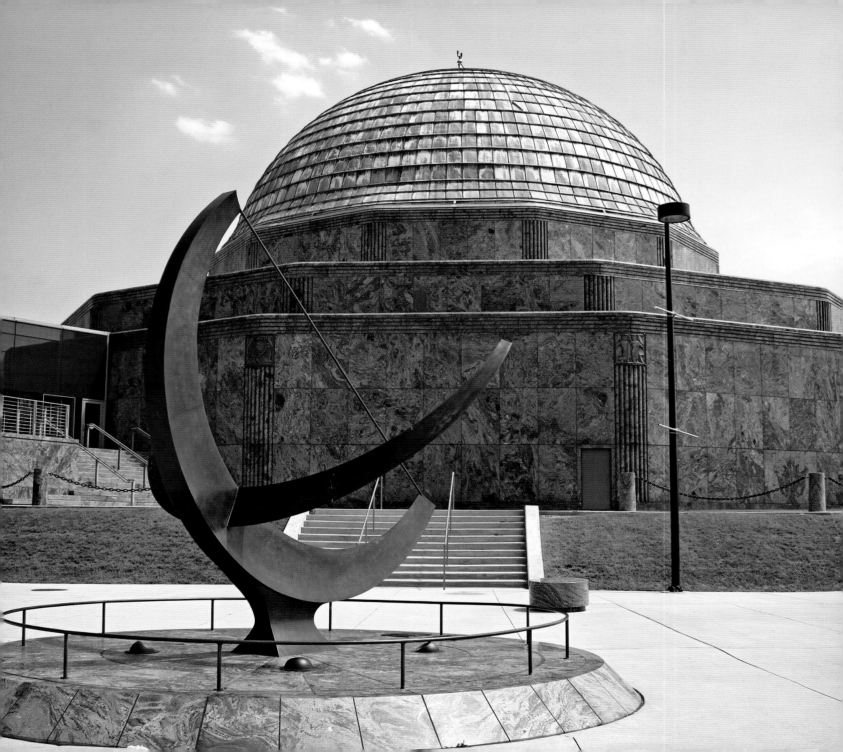

Left: Adler Planetarium and Astronomy Museum is crowned by the domed Sky Theater. The thirteen-foot bronze sundial created by sculptor Henry Moore was installed in 1980.

Below: Ivy entwines a stone figure gracing a building at the University of Chicago.

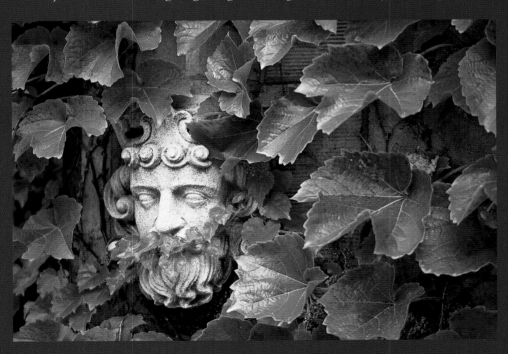

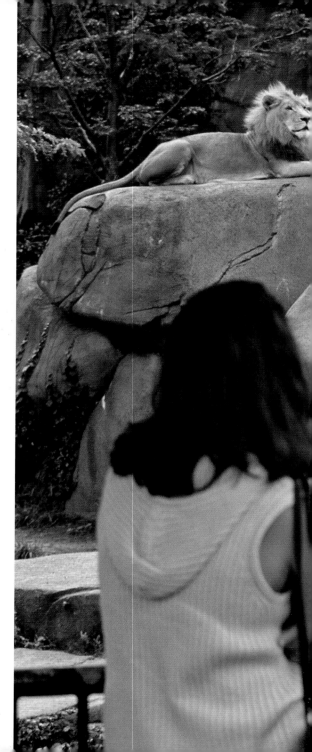

Right: African lions lounge in Lincoln Park Zoo, which was founded in 1868. The zoo is free and open every day of the year.

Below: Completed in 1887, the Abraham Lincoln Monument is one of the oldest public sculptures in Chicago.

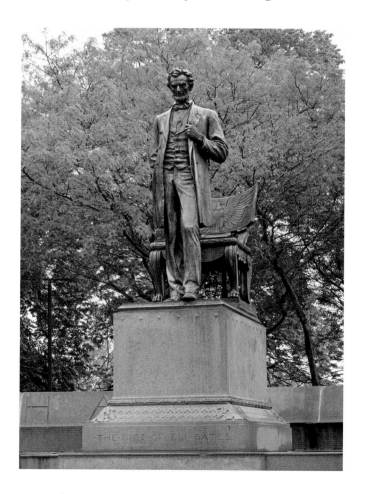

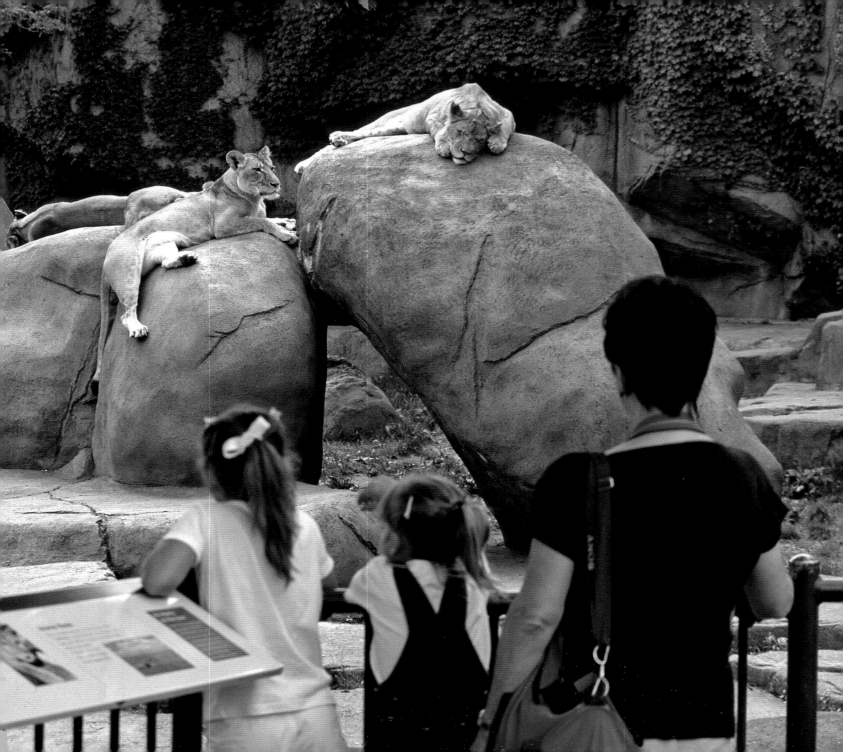

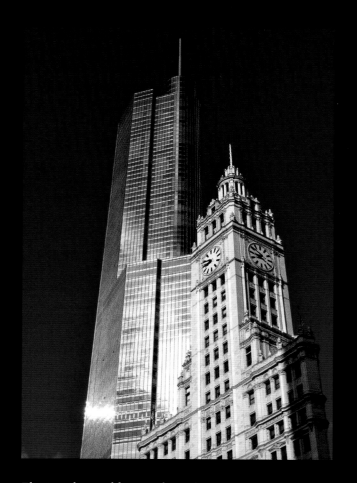

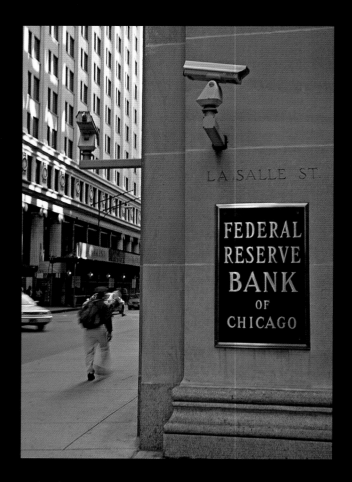

The Wrigley Building anchors the southern end of Chicago's "Magnificent Mile." Behind it rises Trump International Hotel and Tower.

Federal Reserve Bank of Chicago's rock-solid architecture is symbolic of the bank's reliability.

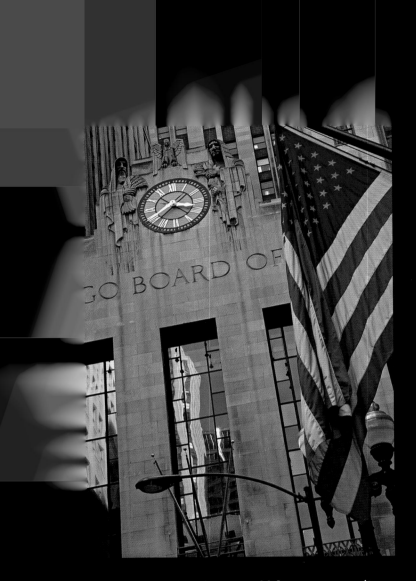

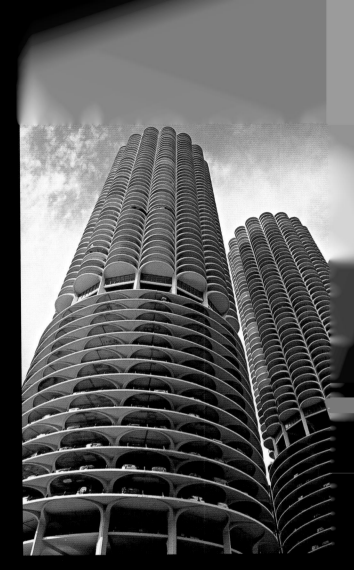

Chicago Board of Trade is a world-famous commodity
futures exchange, trading everything from gold and

Construction of the cylindrical towers of Marina City
began in 1959 and was completed in 1964. Local wags

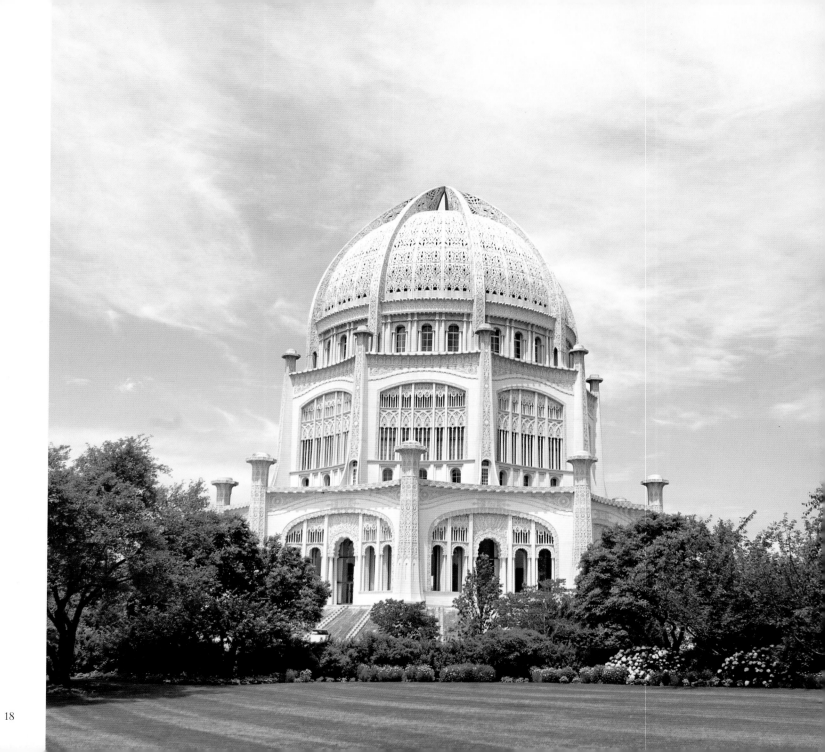

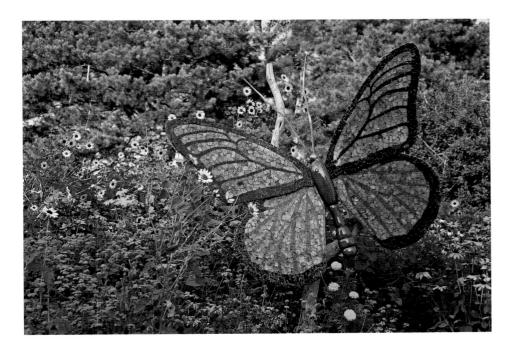

Above: Founded by the Chicago Horticultural Society, the Chicago Botanic Garden features more than twenty display areas on 385 acres. The butterfly sculpture is part of a traveling exhibit about beneficial insects.

Left: The Bahá'í House of Worship, located on the shores of Lake Michigan, has the traditional nine sides and a dome. The domed auditorium is open to people of every religion for prayer and meditation.

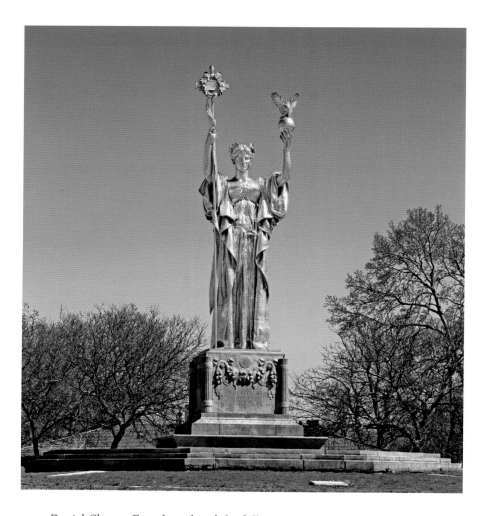

Above: Daniel Chester French sculpted the full-size version of this statue for the World's Columbian Exposition that opened in 1893. This one-third size replica in Jackson Park is variously called *Republic* or *Golden Lady*.

Right: Navy Pier attracts more than eight million visitors each year. The entertainment, rides, and attractions are complemented by unique restaurants and shops.

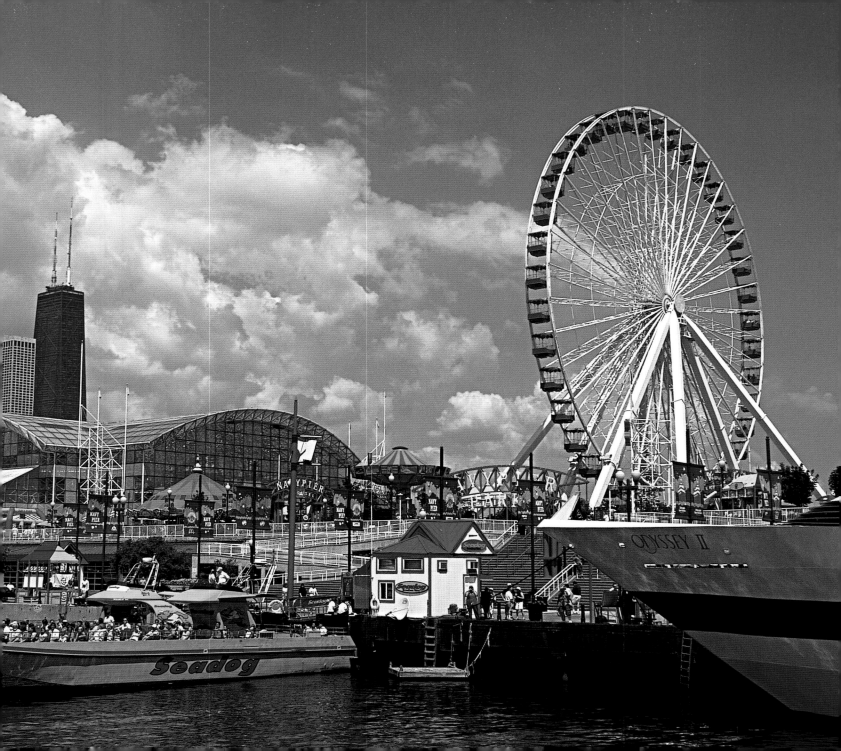

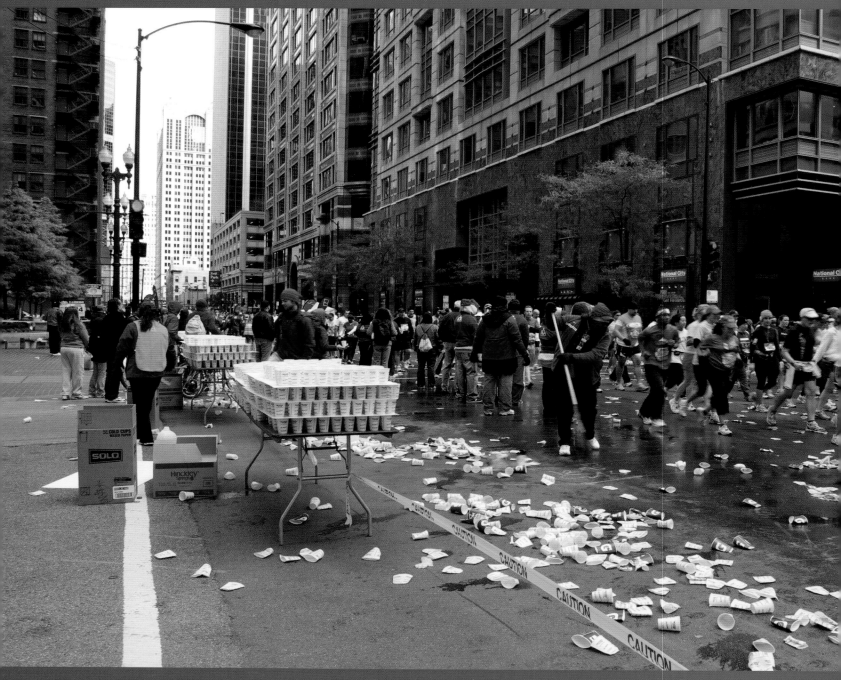

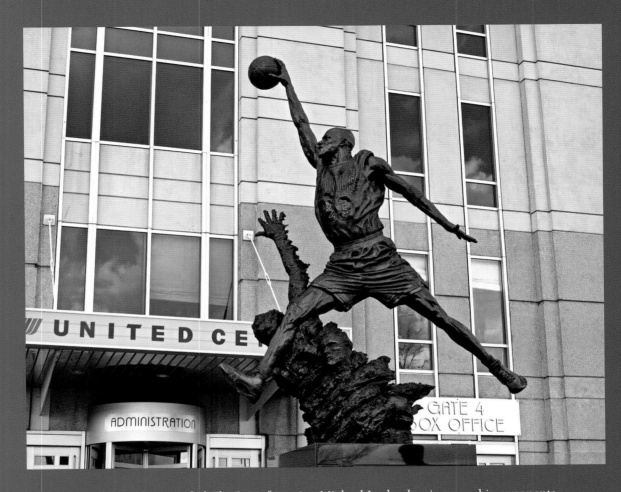

Above: The bronze sculpture titled *The Spirit* featuring Michael Jordan leaping over his opponents is seventeen feet tall and weighs 2,000 pounds.

Left: The Chicago Marathon's history stretches back to 1905. Today branded as the Bank of America Chicago Marathon, the elite race hosts nearly 40,000 finishers each year.

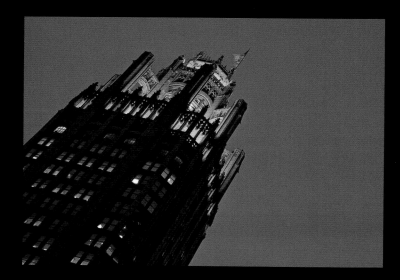

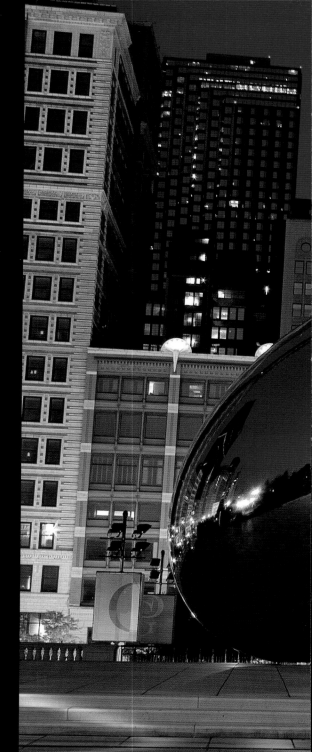

Above: The design for this building won an international competition for "the most beautiful office building in the world" held by the *Chicago Tribune* in 1922. The flying buttresses give Tribune Tower its distinctive silhouette.

Right: The polished surface of *Cloud Gate*, a public sculpture created by Anish Kapoor, reflects the Chicago skyline. The sixty-six-foot-long steel sculpture is the centerpiece of AT&T Plaza and attracts thousands of visitors, who marvel at the distorted images reflected on the sculpture's surface.

Anish Kapoor. *Cloud Gate*, 2006. Copyright Anish Kapoor.

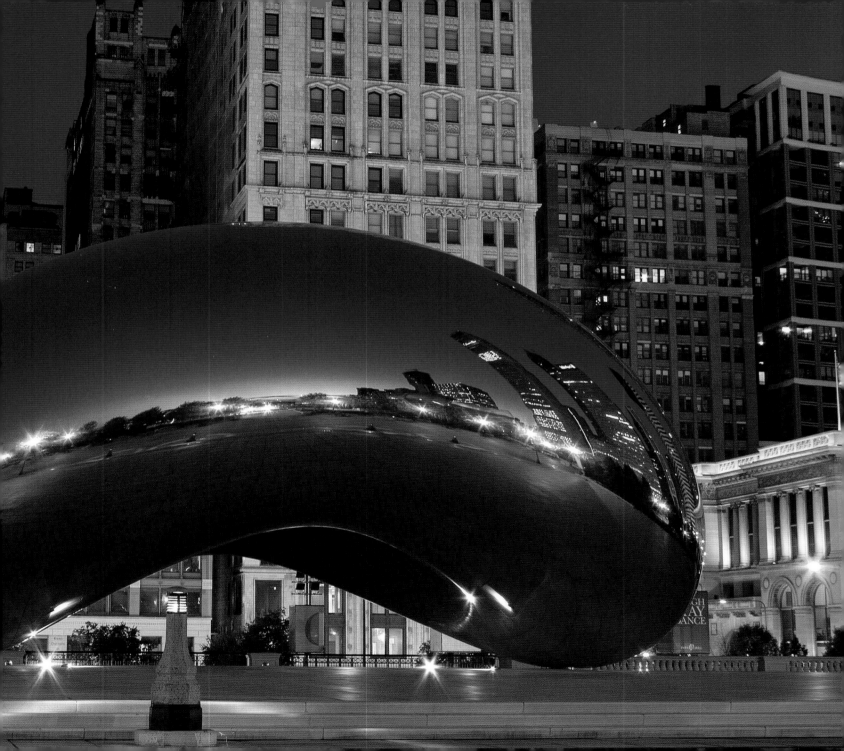

Left: The city of Chicago was incorporated with the motto *Urbs in Horto,* meaning "city in a garden." Tulips are among the city's signature plant species, seen here on Michigan Avenue.

Below: A prairie rose opens its blossom at 70-acre Somme Prairie Nature Preserve, which is working to restore native marsh, wet prairie, mesic prairie, and savannah. Several other prairie restorations are underway in the region, including the 16,000-acre Midewin National Tallgrass Prairie southwest of Chicago.

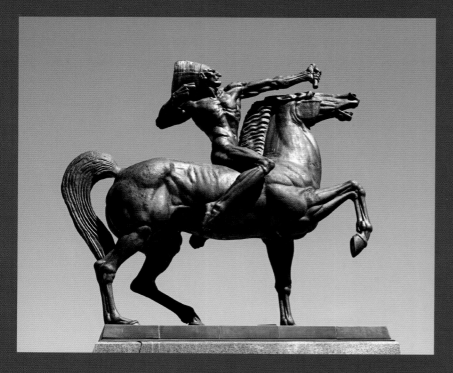

Above: *The Bowman* was sculpted by Ivan Mestrovic and installed in Grant Park in 1928. Its nearby brother sculpture is *The Spearman*.

Right: Completed in 1919, the French Gothic Revival architecture of Saint James Chapel inspired generations of students at Archbishop Quigley Preparatory Seminary. The chapel and school buildings now serve the Archdiocese of Chicago as the Archbishop Quigley Center.

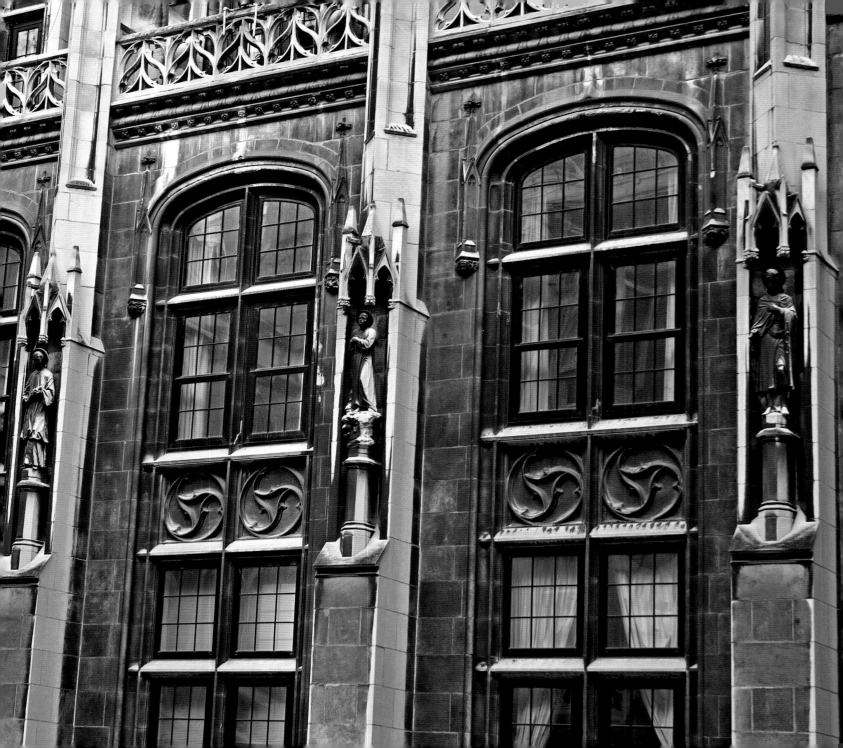

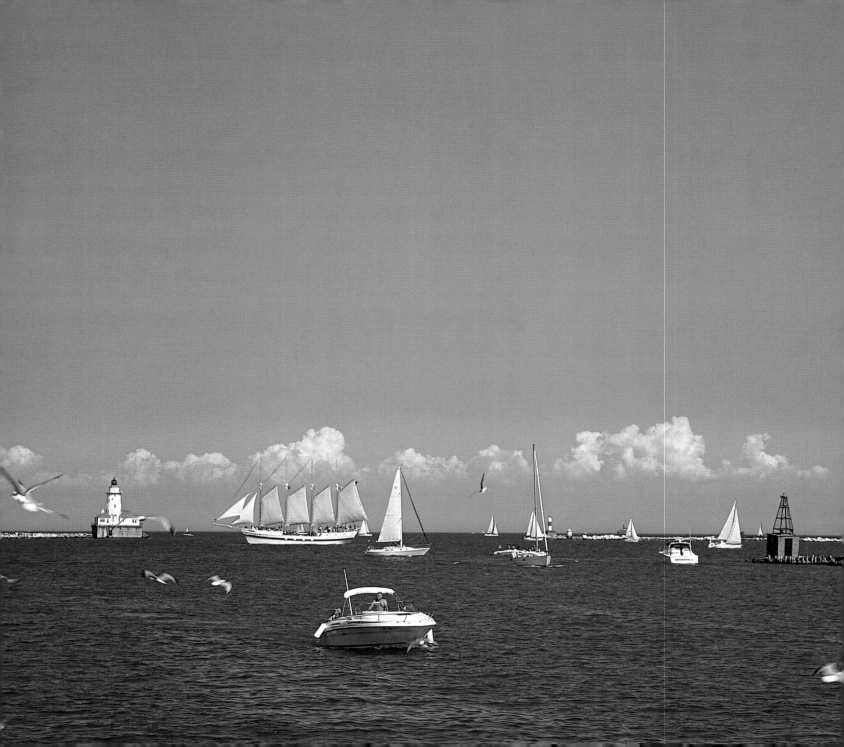

Left: Recreational boating is high on the list of outdoor pleasures for Chicago residents. Chicago Park District operates the nation's largest municipal harbor system, with nine lakefront harbors that can accommodate more than 5,000 boats.

Below: Chicago Harbor Light was first lit in 1893, and it still operates today.

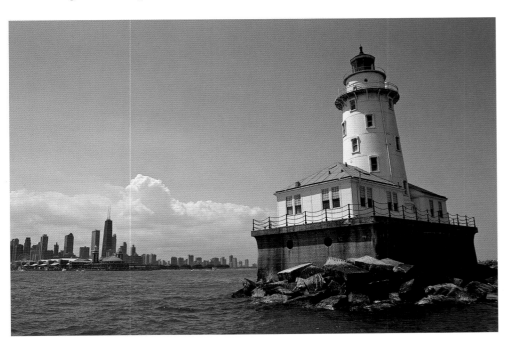

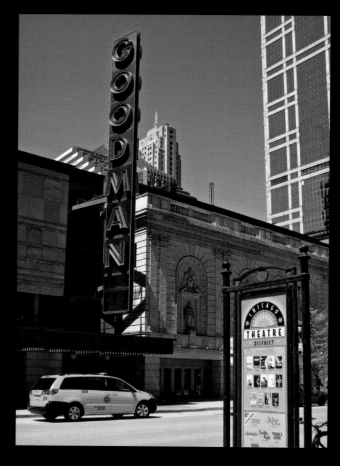

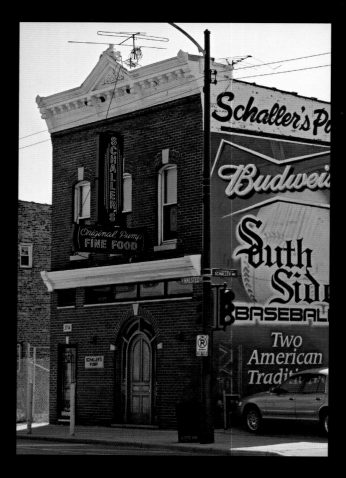

Goodman Theatre, established in 1925, is a premier venue for live performances of classic and contemporary works.

Schaller's Pump is the oldest restaurant/bar still operating in Chicago. It has hosted politicos since its opening in 1881.

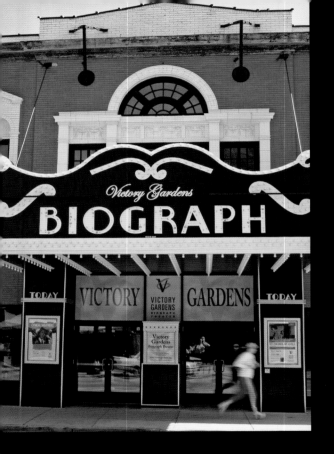

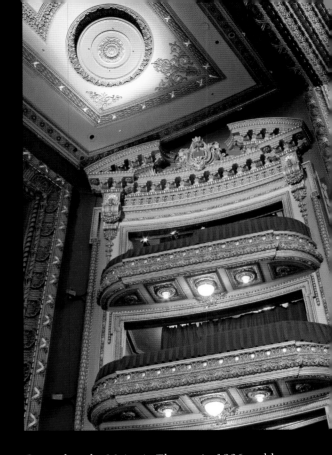

The Victory Gardens Biograph has a lively mission of developing and producing new plays, favoring Chicago playwrights. Its history also is quite lively: on July 22, 1934, the FBI shot down notorious gangster John Herbert Dillinger as he left the Biograph with two lady

Opened as the Majestic Theatre in 1906 and later operated as the Shubert and the LaSalle Bank Theatre, today's Bank of America Theatre still hosts tours of major Broadway shows. These gilt box seats have seen much since the vaudeville era.

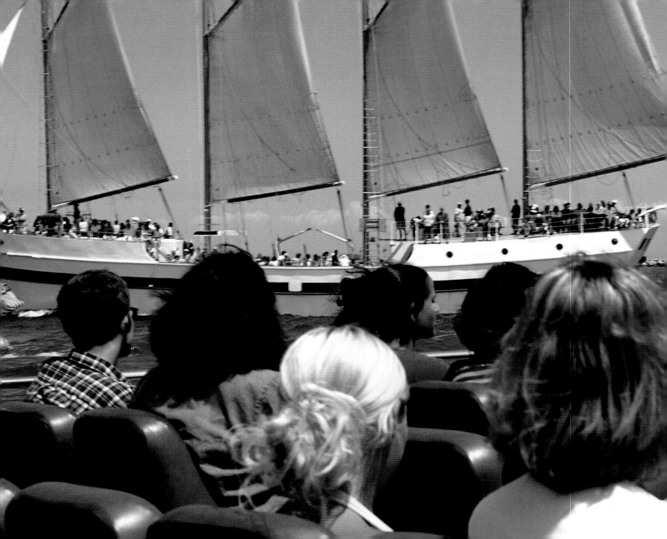

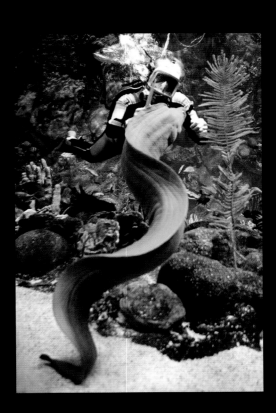

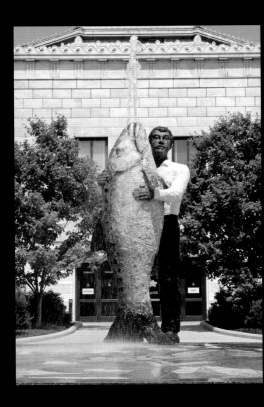

Above, left: A green moray eel watches a diver watching it, at the Shedd Aquarium.
PHOTO COURTESY OF SHEDD AQUARIUM; PHOTO BY BRENNA HERNANDEZ

Above, right: The Stephan Balkenhol sculpture *Man With Fish* stands in the fountain outside the Shedd Aquarium.

Left: Old meets new on Lake Michigan as the tallship *Windy* sails past a Seadog speedboat tour.

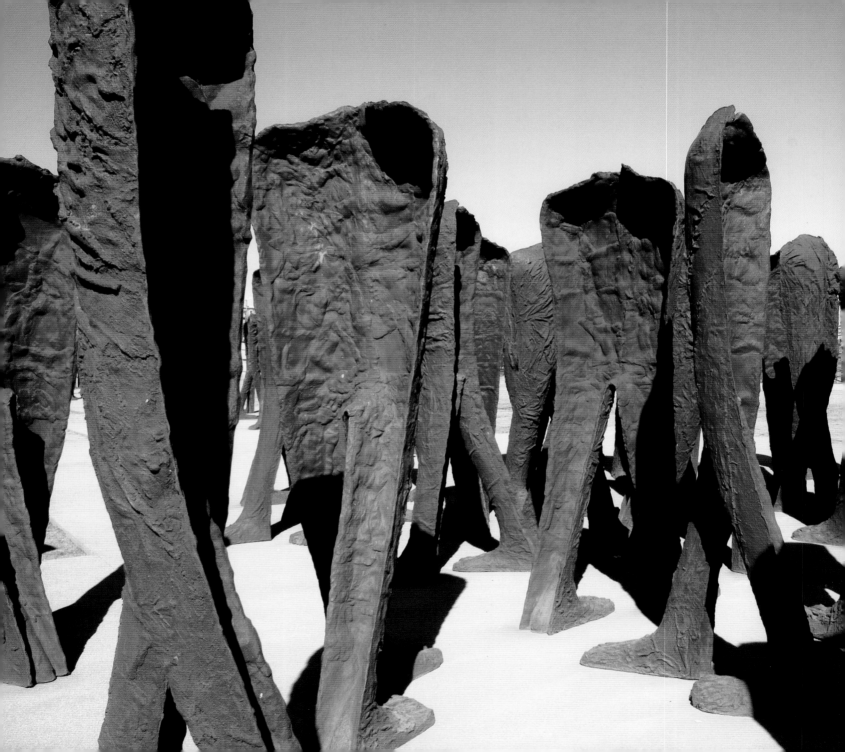

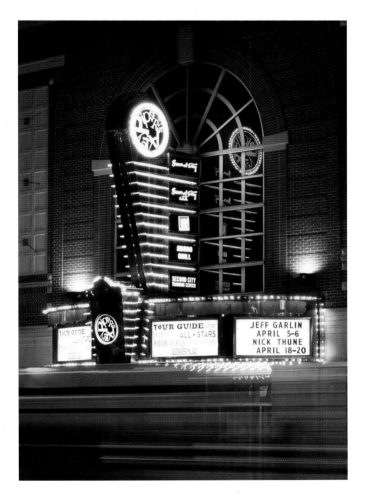

Above: The Piper's Alley complex houses shops, restaurants, and a heap of Chicago humor; the complex is home to the popular comedy group Second City.

Left: Agora is the Greek word for "marketplace." Sculptor Magdalena Abakanowicz's 106 nine-foot-tall headless cast-iron figures in Grant Park have subtle differences that become intriguingly apparent when you walk among them.

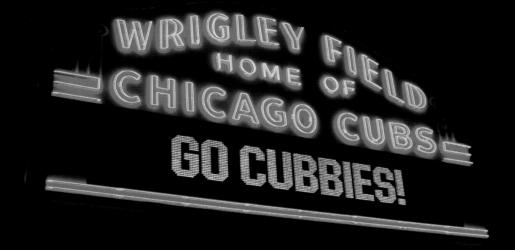

Above: Wrigley Field, built in 1914, has been the home of the Chicago Cubs since 1915. The first National League game was played here on April 20, 1916; the Cubs beat the Cincinnati Reds seven to six, in eleven innings.

Right: An exuberant display of fireworks marks a home run by the Chicago White Sox. The American League Team has been playing at U.S. Cellular Field since its completion in 1991.

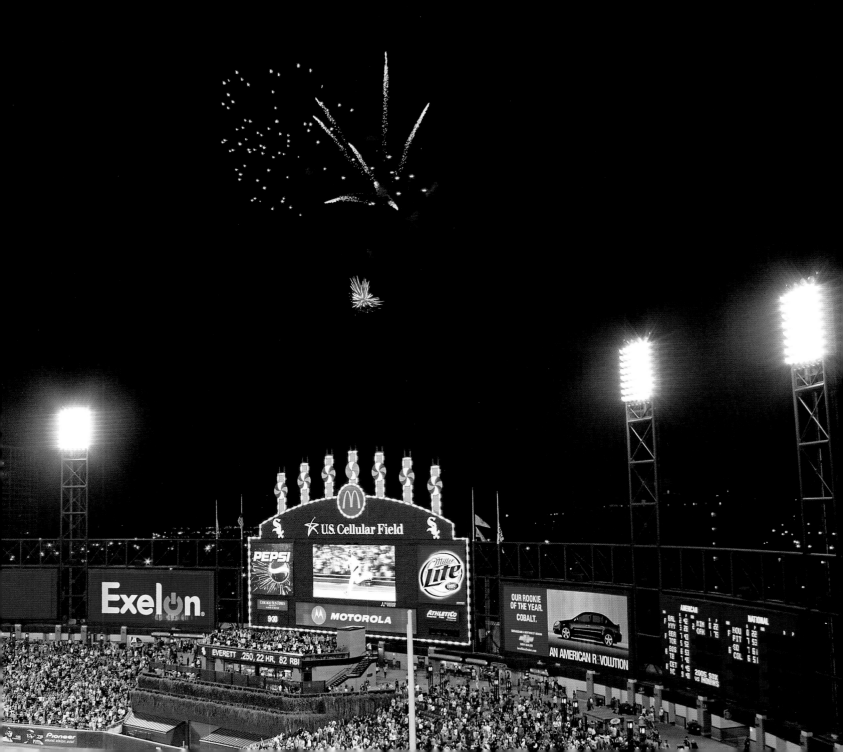

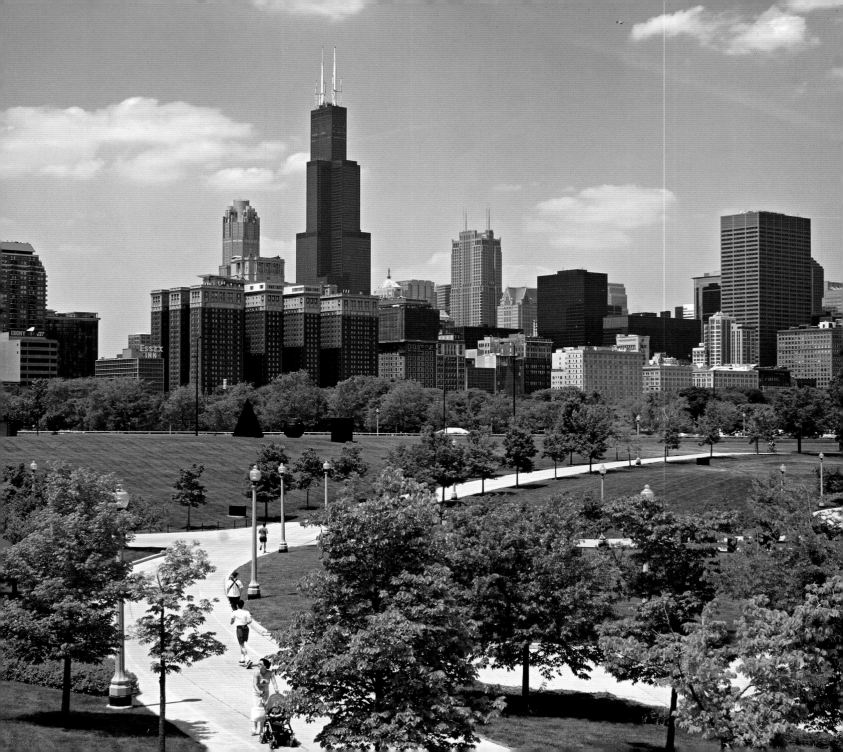

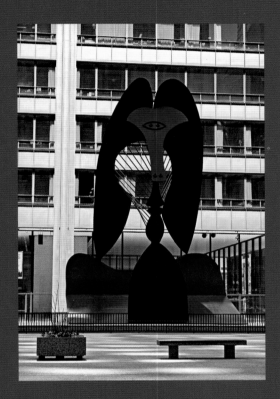

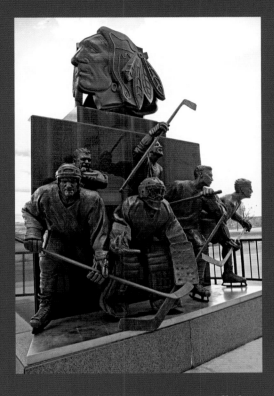

Above, left: Pablo Picasso's sculptural gift to the city was very controversial when it was installed at the Civic Center Plaza in 1967 (now called the Daley Center). Today the fifty-foot-high piece is a cherished landmark of downtown Chicago.

Above, right: *Badge of Honor* commemorates the 75th anniversary season of the Chicago Blackhawks' membership in the National Hockey League.

Left: The city skyline, including Willis Tower (formerly Sears Tower), rises above the 57 acres of Museum Campus parkland.

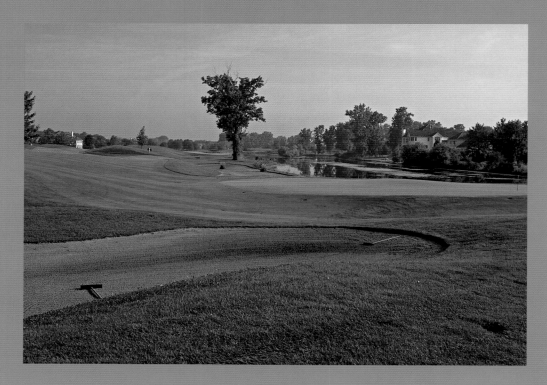

Above: The view from the green at Hole 6, Ruffled Feathers Golf Course. Many courses in the region are open to the public, including six managed by the Chicago Park District.

Right: Lincoln Park Conservatory features four display houses: Palm House, Fern Room, Orchid House, and Show House. Each showcases exotic plants, including water lilies, tropical palms, and ancient ferns.

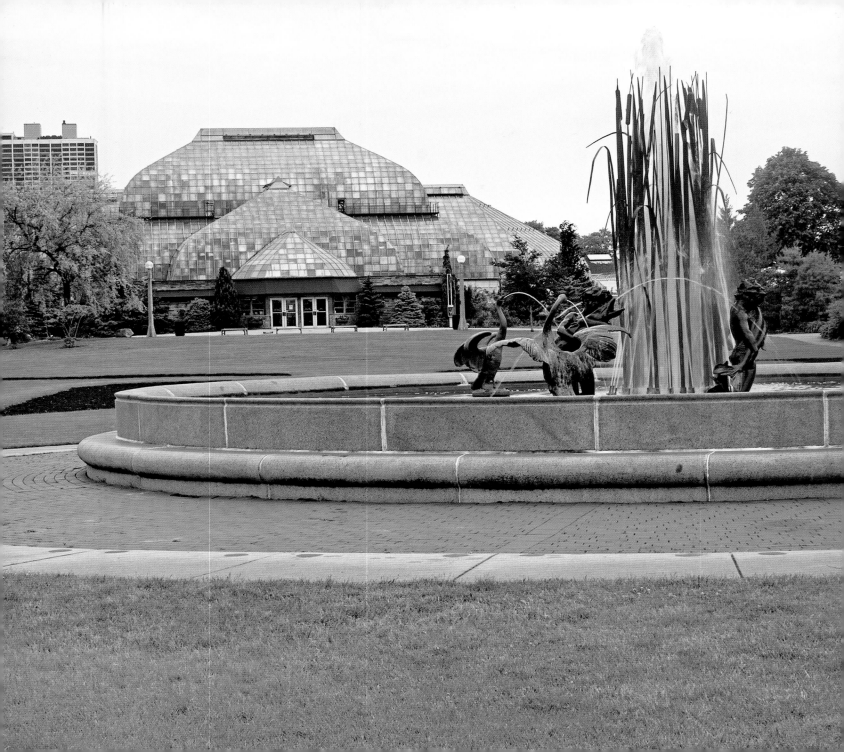

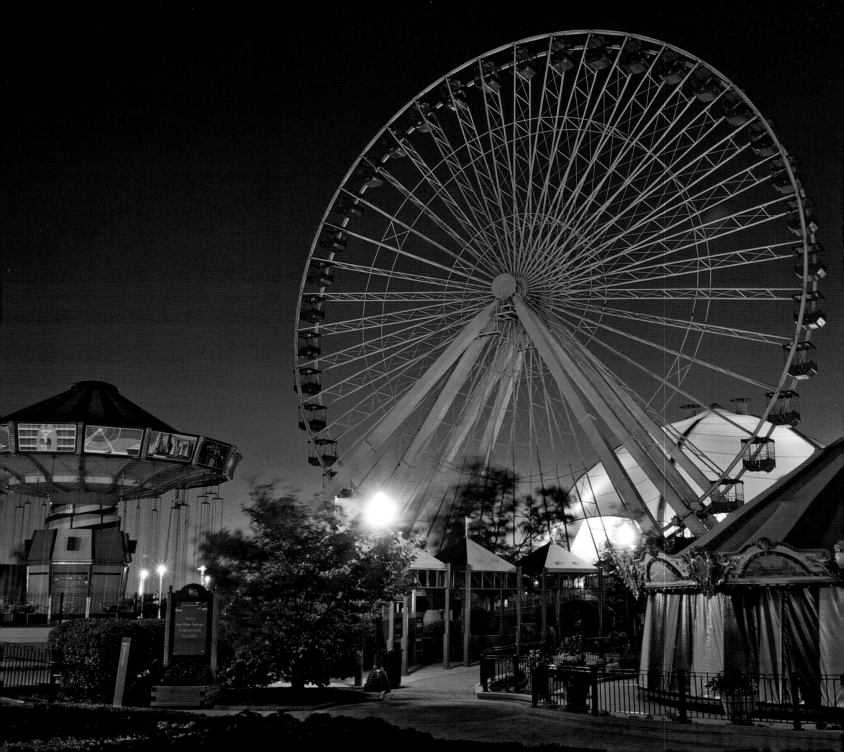

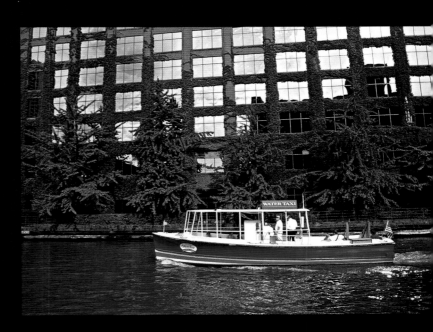

Above: Water taxis on the Chicago River help you avoid vehicle congestion on busy urban streets.

Left: Navy Pier, a 3,300-foot-long lakefront promenade, has served as the city's playground since it opened in 1916.

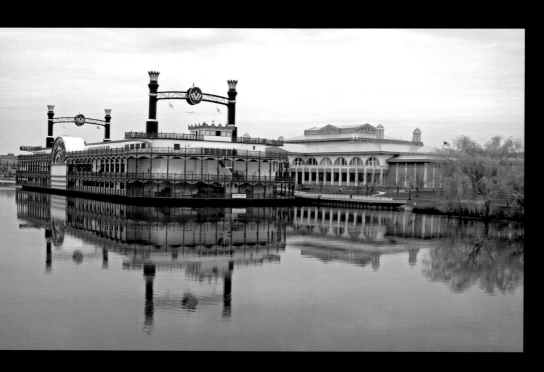

Above: Grand Victoria Casino is housed in a riverboat moored on the Fox River in Elgin.

Right: Installed in Millennium Park in 2004 by leading landscape designers, the five-acre Lurie Garden hosts an amazing variety of hardy plants. The Garden also provides educational lectures and workshops for those interested in sustainable gardening.

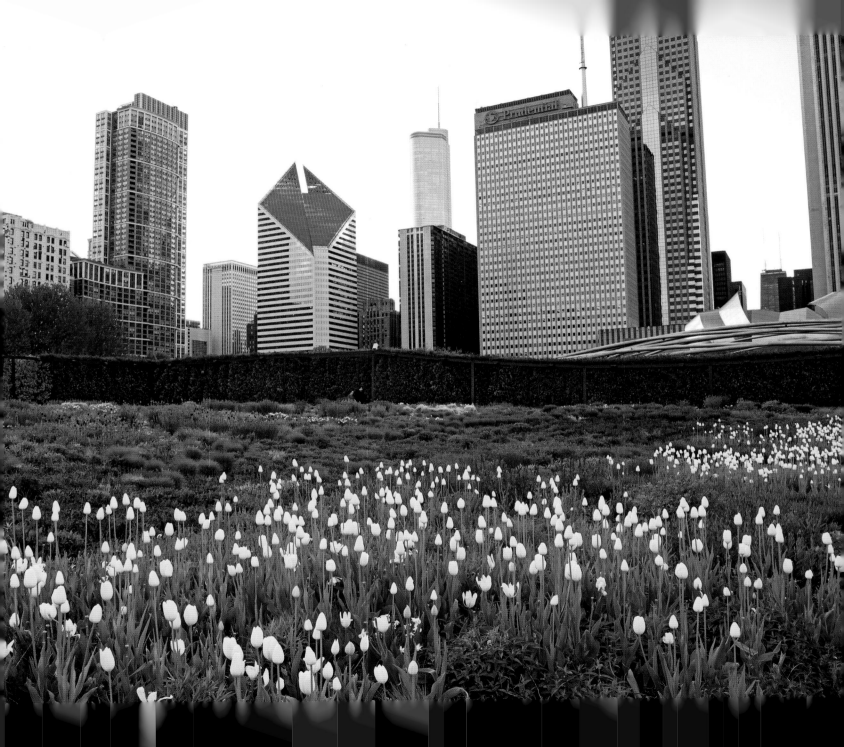

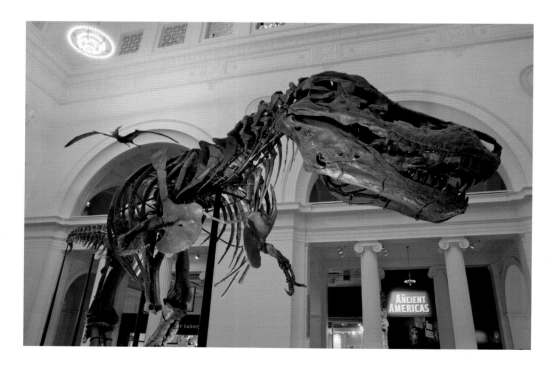

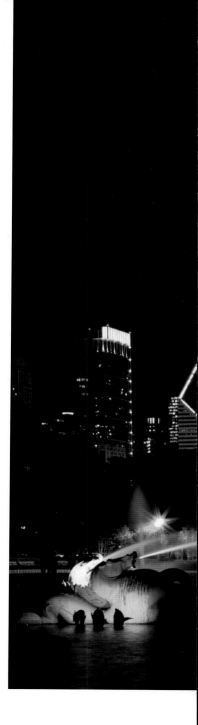

Above: Forty-two feet long and at least 65.5 million years old, "Sue" the *Tyrannosaurus rex* is a prized possession of the Field Museum of Natural History. Discovered in 1990, Sue remains one of the most complete *T. rex* specimens ever found.

Left: One of the largest fountains in the world, Clarence F. Buckingham Memorial Fountain thrills Grant Park visitors with its 20-minute displays.

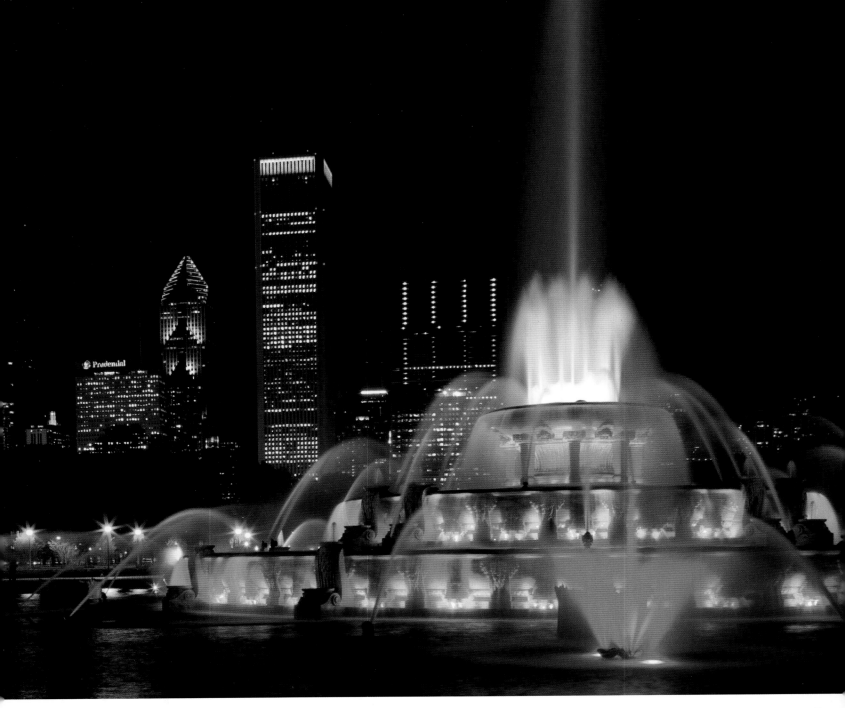

Right: The Jay Pritzker Pavilion features a revolutionary sound system that employs overhead concentric speakers and precise digital delays that mimic the acoustics of an indoor concert hall.

Below: Hankering for a hot dog and malt? Superdawg Drive-In has been serving at the same location since 1948.

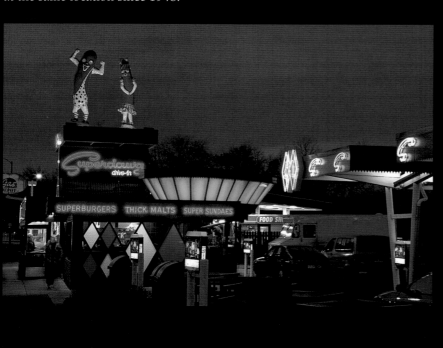

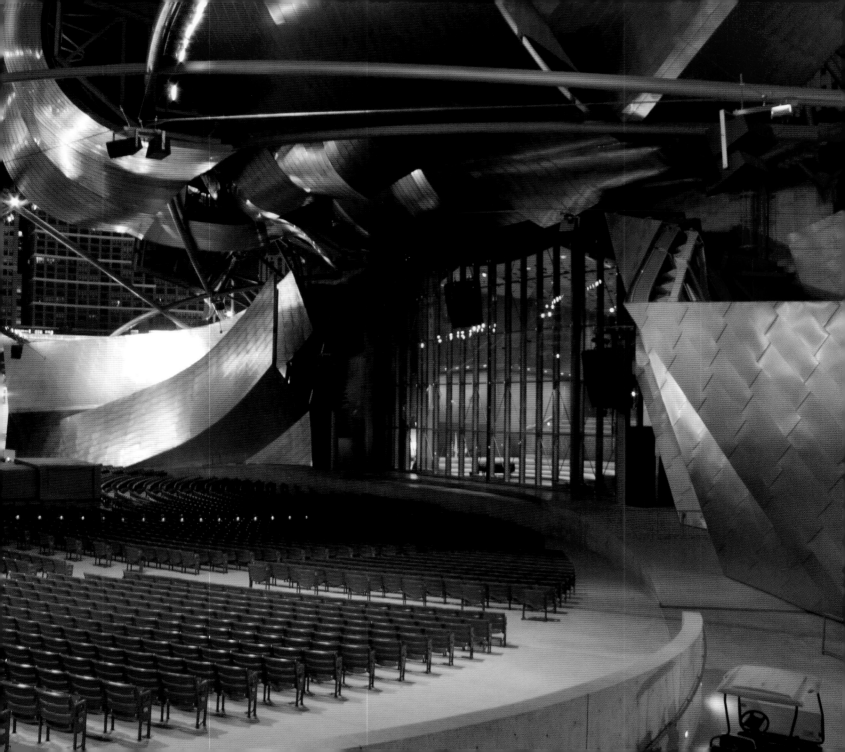

the remains of many of Chicago's departed,
rious gangsters.

miles of beautiful Lake Shore Drive to pedal-
ing May.

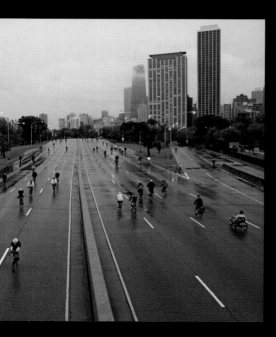

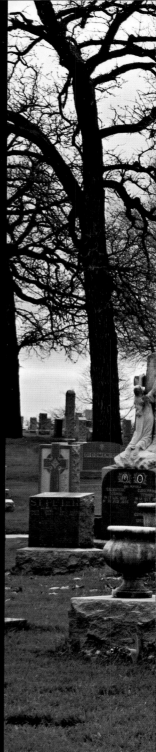

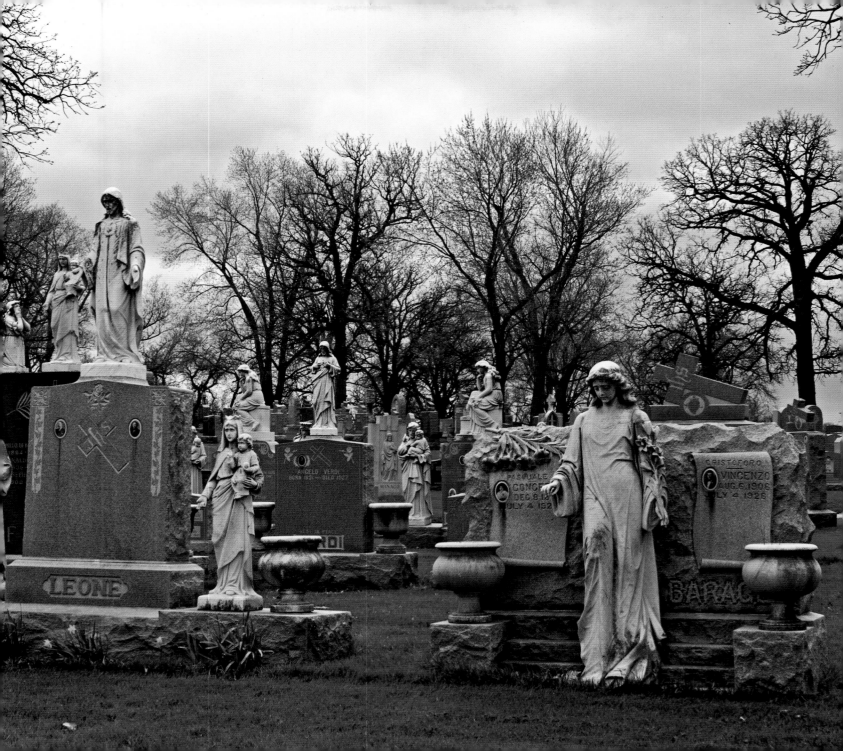

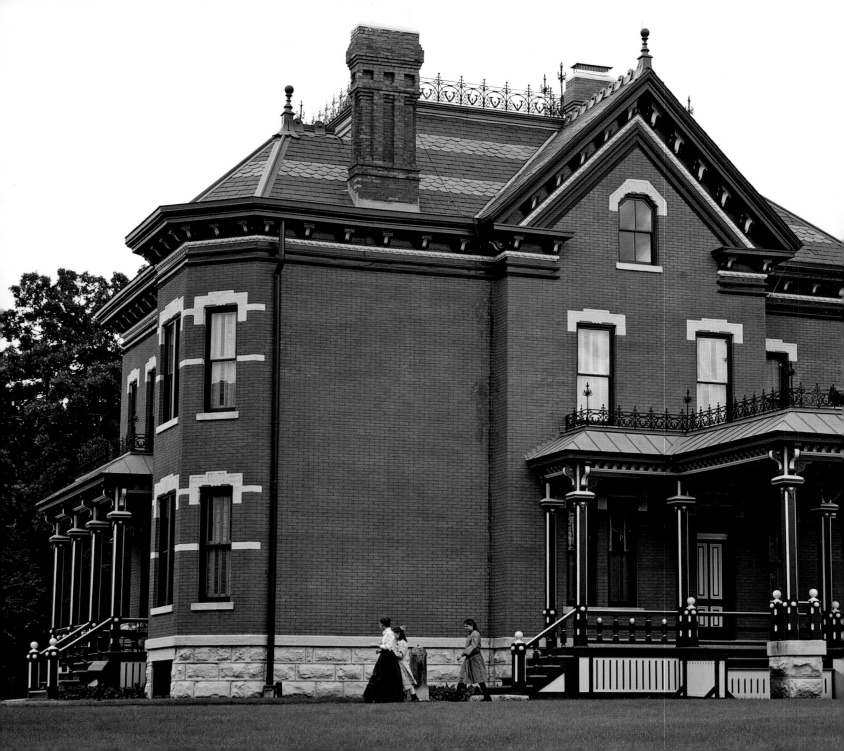

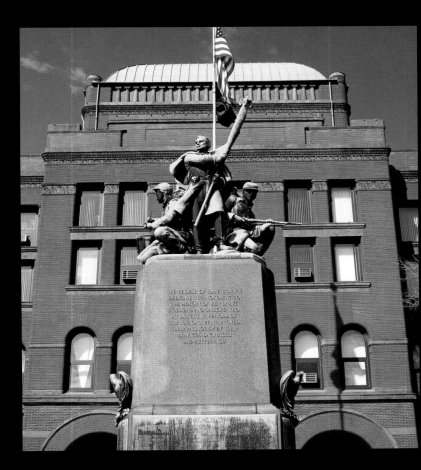

Above: The old four-story Kane County Courthouse in Geneva has eleven hand-painted murals inside. Outside, a memorial honors the sacrifices made by soldiers and sailors in war.

Left: The Martin Mitchell Mansion was built in 1883. A $2.8 million renovation completed in 2003 restored the structure, and now visitors to Naper Settlement can see the exquisite details.

Right: Above it all, the "L" zips across downtown with nary a stoplight or traffic jam.

Below: A coyote shows the resilience of its species by surviving near Wilson Hall on the extensive campus of Fermilab (Fermi National Accelerator Laboratory).

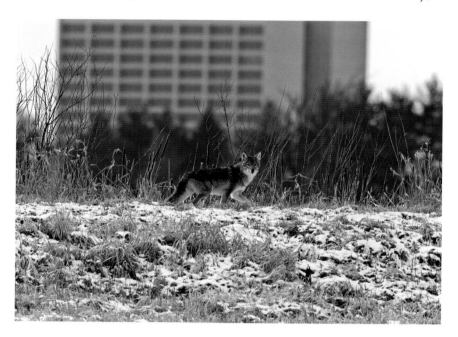

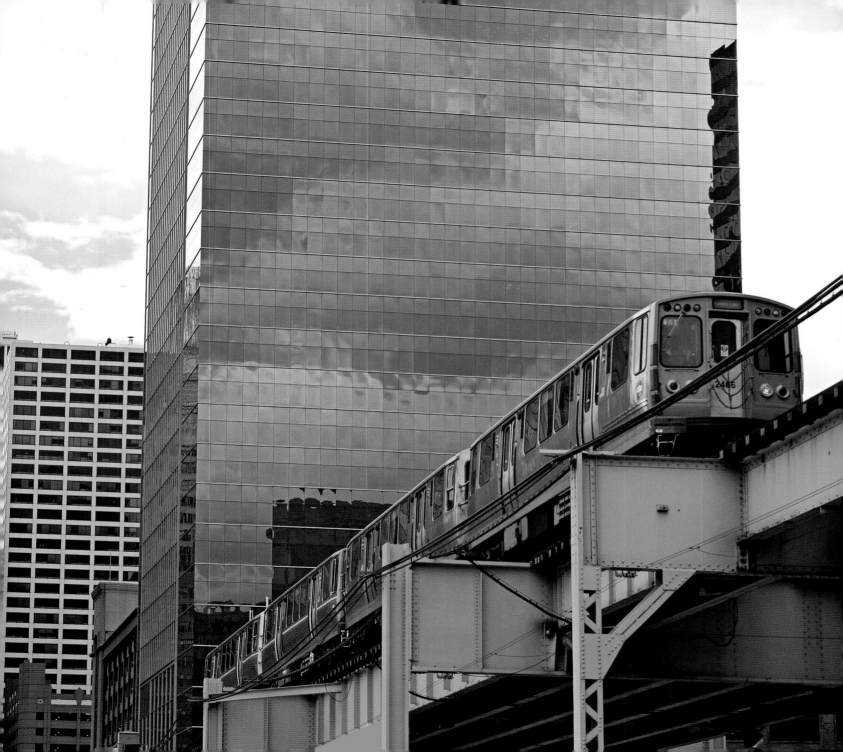

DuPage Children's
301
301
MU

Museum Hours:
Monday 9-1
Tuesday 9-5
Wednesday 9-8
Thursday 9-5
Friday 9-5
Saturday Noon-5
Sunday Noon-5

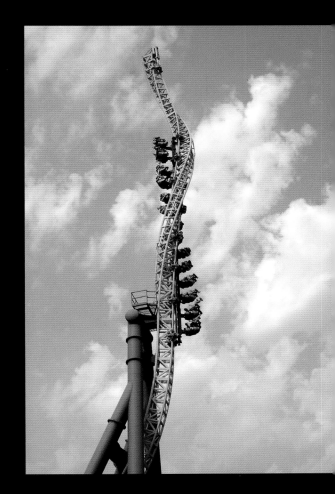

Above: Roller coasters continue to offer thrills at Six Flags Great America amusement park.

Left: DuPage Children's Museum specializes in innovative experiential learning about how science, art, and math work together in the world. The museum offers classes, performances, exhibits, and mini camps.

Right: Operated on this site since 1893, the Art Institute of Chicago features permanent and changing exhibits, as well as a famous school, and workshops, programs, performances, and symposiums.

Below: Installed on the Marshall Field and Company store that was built on State Street between 1892 and 1914, Macy's Clock keeps shoppers on time for their next appointment. In 2006, Federated Department Stores acquired the company and changed all sixty-two of the Marshall Field and Company store names to Macy's.

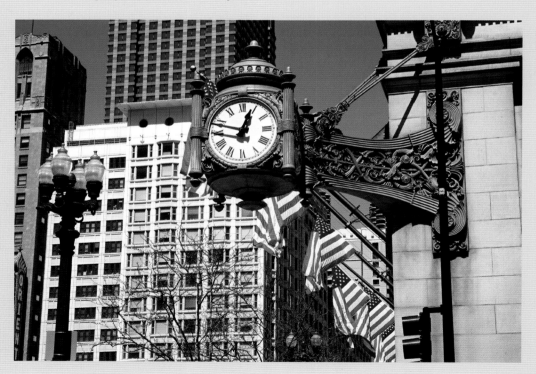

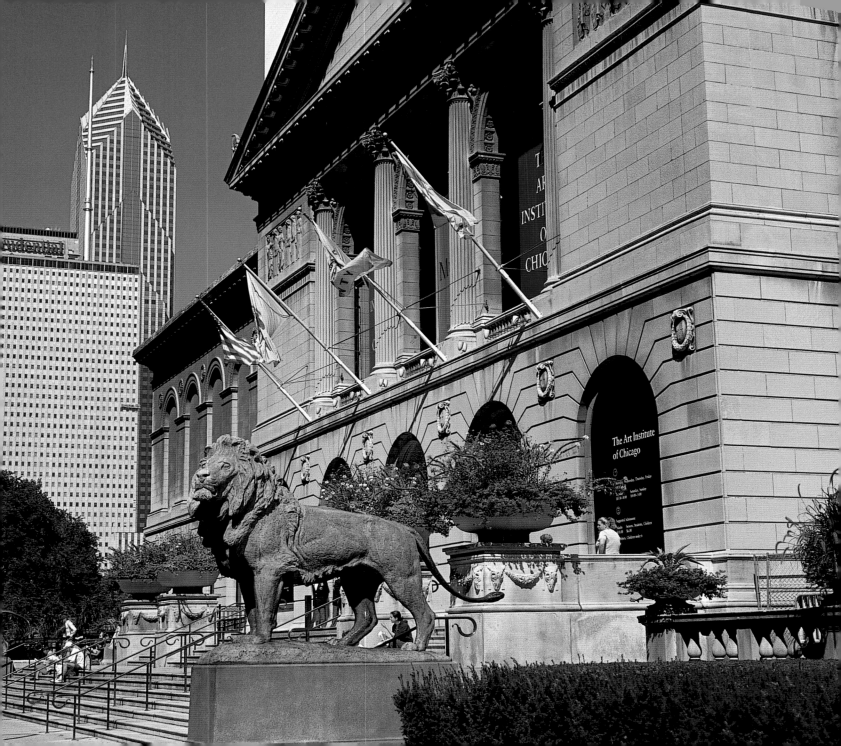

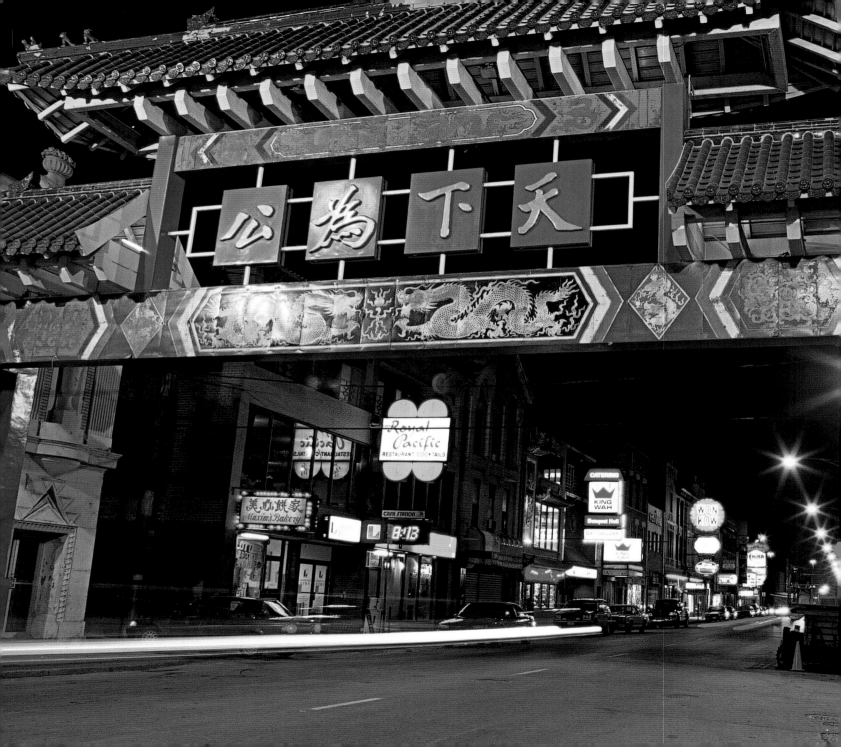

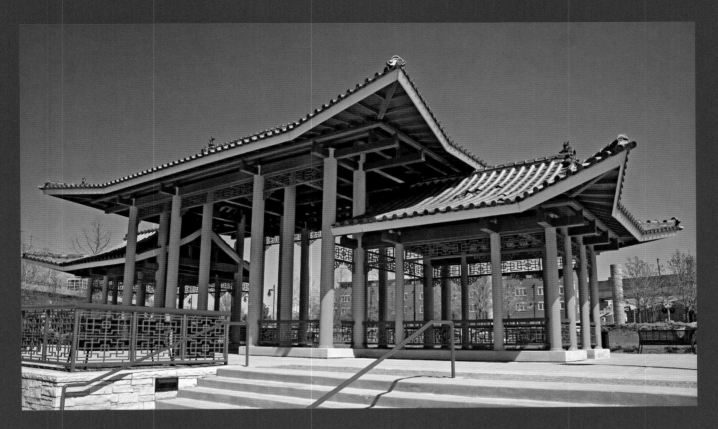

Above: Seeing the need for green space near Chinatown, in 1998 the city transformed an old railyard into Ping Tom Memorial Park, honoring a local civic leader with a riverfront park featuring a playground and a lovely pagoda-style pavilion.

Facing page: The Chinatown Gateway leaves no doubt that you are entering a culturally unique area of Chicago.

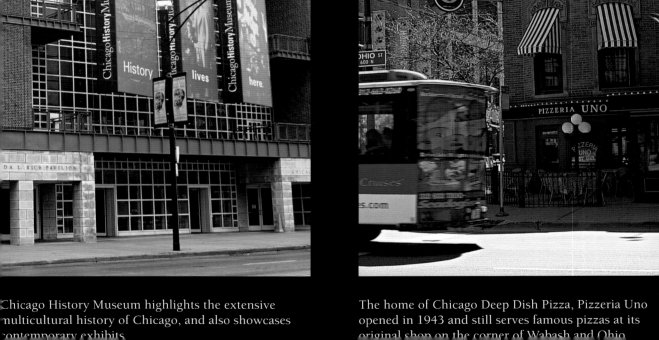

Chicago History Museum highlights the extensive multicultural history of Chicago, and also showcases contemporary exhibits.

The home of Chicago Deep Dish Pizza, Pizzeria Uno opened in 1943 and still serves famous pizzas at its original shop on the corner of Wabash and Ohio.

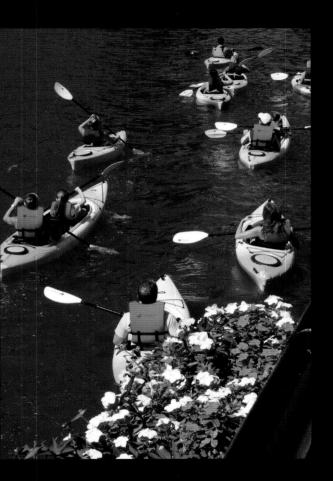

Kayakers take advantage of a sunny summer day, touring the city by way of the Chicago River.

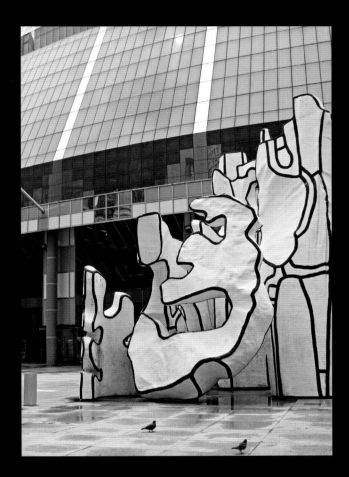

Monument with Standing Beast, a twenty-nine-foot-tall fiberglass sculpture by Jean Dubuffet, was installed at the sixteen-story glass-and-steel James R. Thompson Center in 1984.

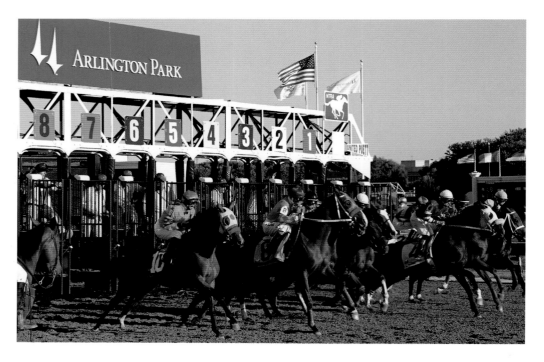

Above: And they're off! Thoroughbreds bolt from the Arlington Park starting gate. The track made racing history in 1981 when it announced a million-dollar turf race.

Right: Chicago's St. Patrick's Day Parade means green everywhere—including in the river.

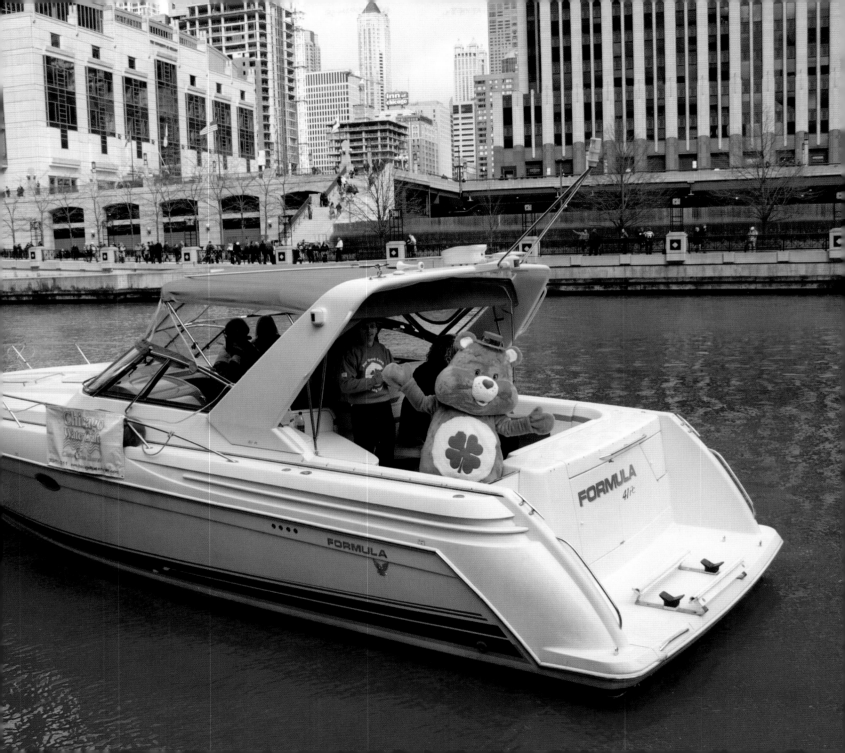

Right: The Harold Washington Library Center, opened in 1991, is named for Chicago's first African-American mayor, a great lover of books.

Below: Designated a Chicago Landmark in 1972, the Rookery boasts an ornate copper stairway. The nickname originated in the 1800s, when pigeons roosted on the temporary water tank and city hall structure that once stood on this site.

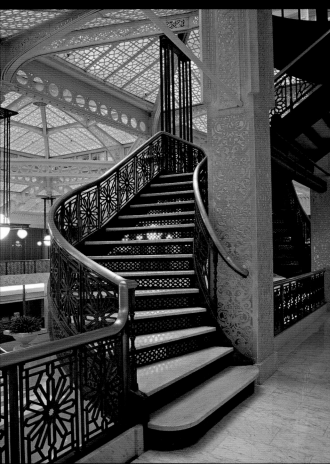

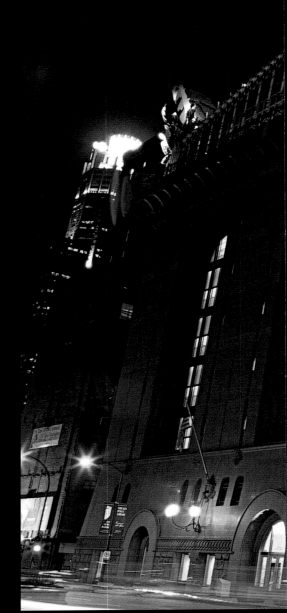

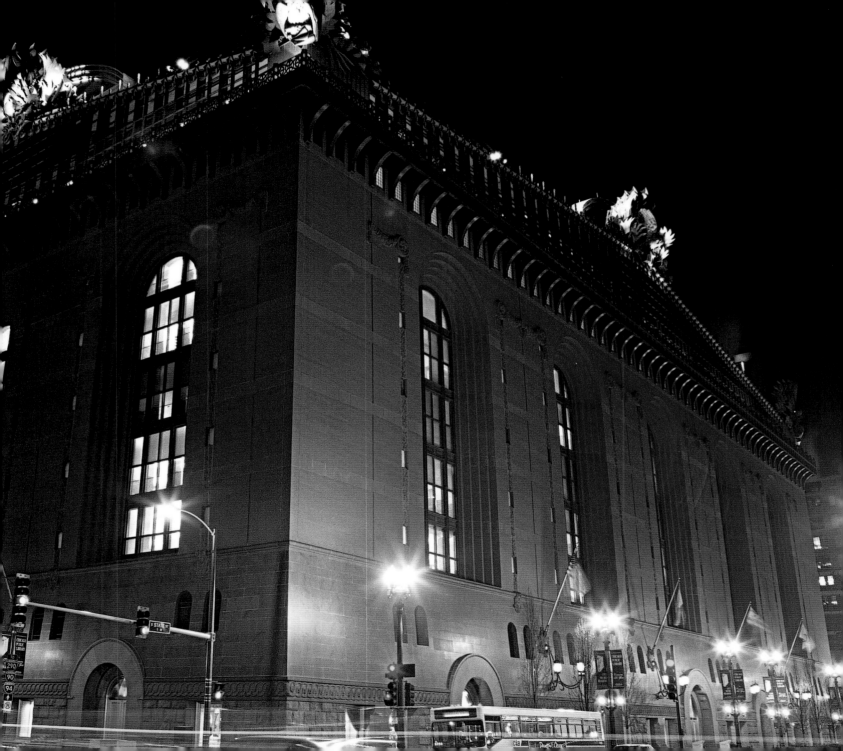

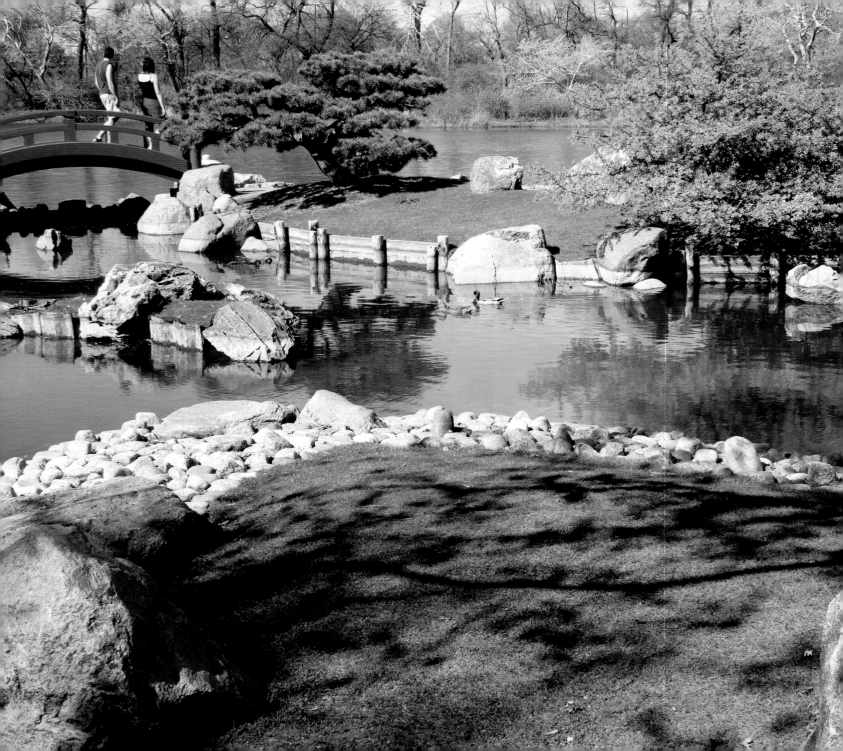

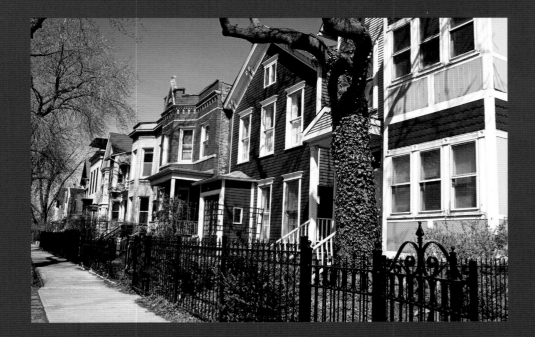

Above: Chicago is famous for its distinct neighborhoods, this one on West Altgeld Street between Halstead and Lincoln.

Left: This peaceful sanctuary, rich with symbols such as the Moon Bridge, graces Wooded Island near the Museum of Science and Industry. It was developed as the Japanese Garden in 1934, restored in the 1980s, and in 1992 renamed Osaka Garden to honor Chicago's sister city in Japan.

Right, top: A great egret searches for a balance point after landing in the top of a tree.

Right, bottom: Lock 6 and the lockkeeper's home along the towpath of the I & M Canal (Illinois & Michigan). Constructed between 1836 and 1848, the canal was the final link in a water route connecting the East Coast and the Gulf of Mexico.

Far right: A rainy afternoon moistens the sand on North Avenue Beach. The trail along the lakefront is popular for walking, running, bicycling, and rollerblading.

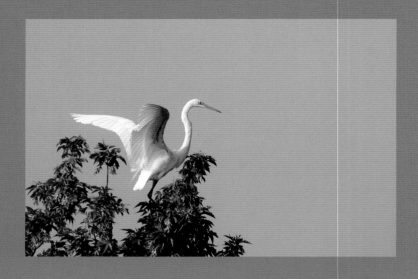

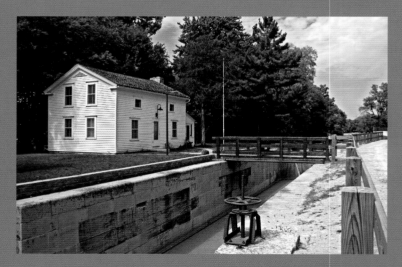

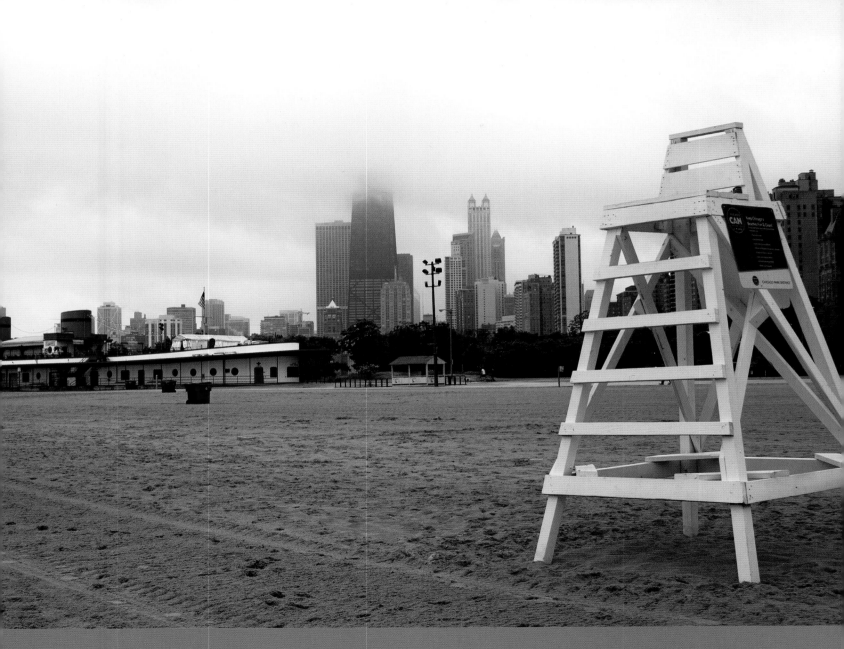

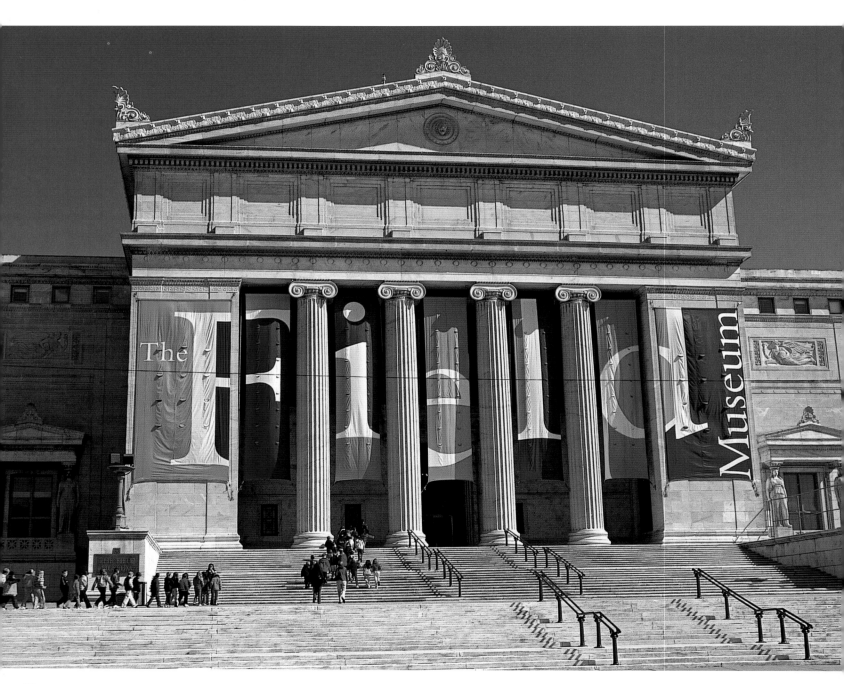

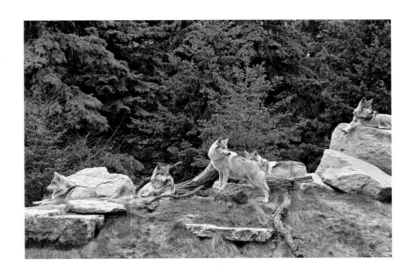

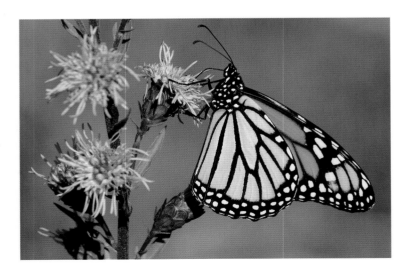

Left, top: Brookfield Zoo, on Indian Lake, shelters a small pack of endangered Mexican gray wolves.

Left, bottom: A monarch butterfly probes for nectar in a savanna blazing star blossom at Hickory Creek Nature Preserve.

Far left: The Field Museum's core collection includes the biological and anthropological pieces displayed in the World's Columbian Exposition of 1893.

Facing page: The clock tower of Dearborn Station kept passengers apprised of the time until rail service here ceased in 1971. Today this Chicago Landmark is a commercial center.

Below: In 1858, Dwight Lyman Moody started a Sunday School mission in a Chicago saloon. Today, the D. L. Moody Memorial Church continues to instruct people about core Biblical messages.

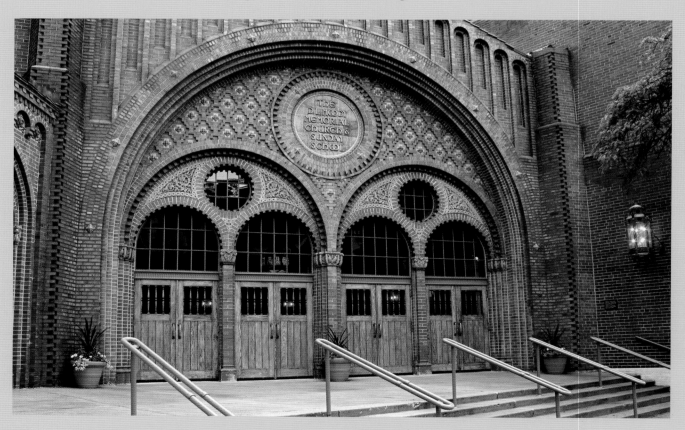

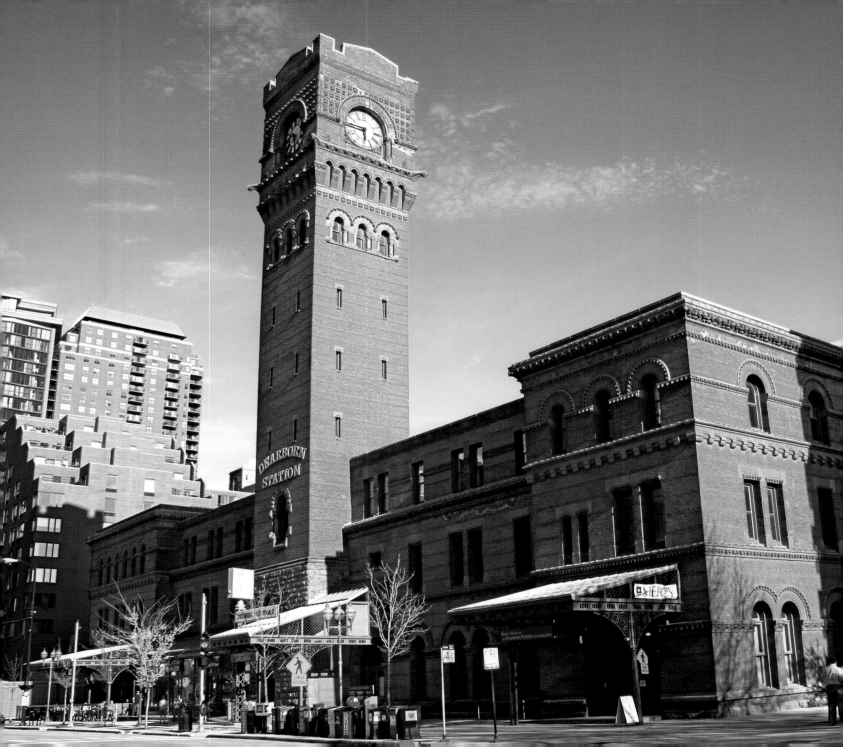

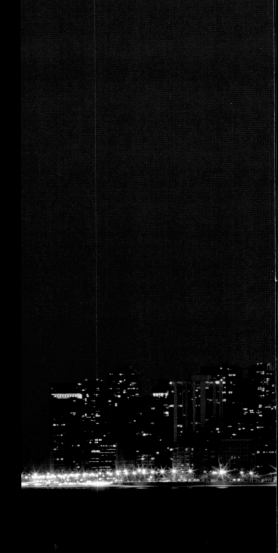

Right: The high-watt Chicago nightscape lights up as sunlight fades away on another workday.

Below: In 1934, "Billy Goat" Sianis purchased the Lincoln Tavern for $205. His check bounced, but the first weekend of business brought in enough to make the payment good.

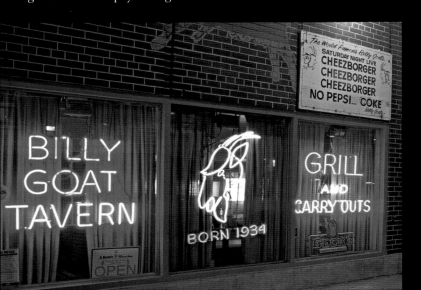

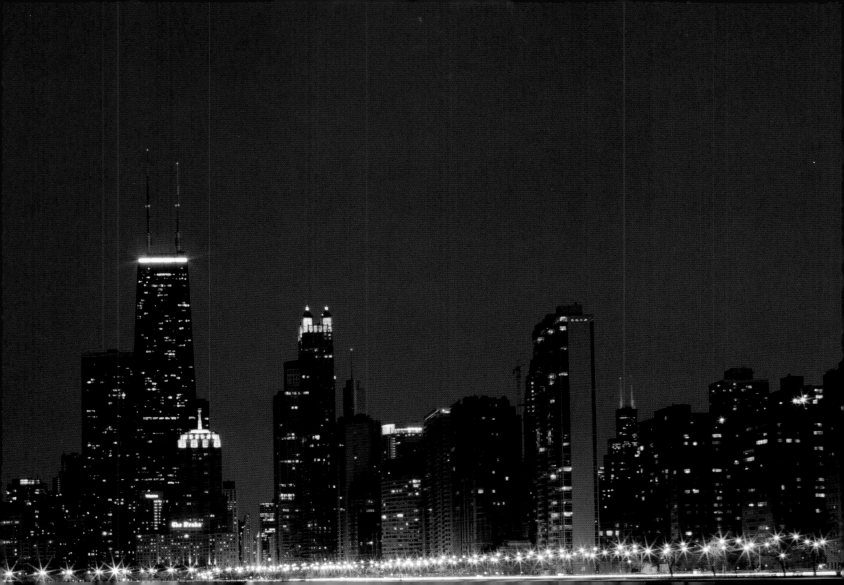

PHOTO BY SANDY TANG

GERALD D. TANG'S business career brought him and his family to the Chicago area in 1988. After he retired, Tang launched his new life's work as a photographer. He has captured many thousands of nature, wildlife, and travel photos, concentrating on Chicago and the Great Lakes area, but ranging to other parts of North America and as far as Africa, China, and Costa Rica.

Tang's work has appeared in numerous books, exhibits, calendars, magazines, and corporate publications, including publications by AAA, *Audubon*, *BBC Wildlife*, Canon/Dentsu America, Defenders of Wildlife, *Endless Vacation*, *Family Circle*, *FamilyFun*, The Field Museum, *Mother Earth News*, *National Geographic*, National Turkey Federation, *National Wildlife*, *Outdoor Life*, *Real Simple*, *REI Adventures*, *Sciences et Avenir*, Sierra Club Outings, The Nature Conservancy, *Voyager*, and *World Book*.

Tang is a charter member of the North American Nature Photography Association.

Go to www.tangsphoto.com to view his stock photos.

Right: Finished in 1869, the Joliet limestone tower of the Chicago Avenue Water Tower is known to locals as simply the Old Water Tower. This cherished landmark survived the Great Chicago Fire of 1871, and it stands today as a symbol of the city's resilience.

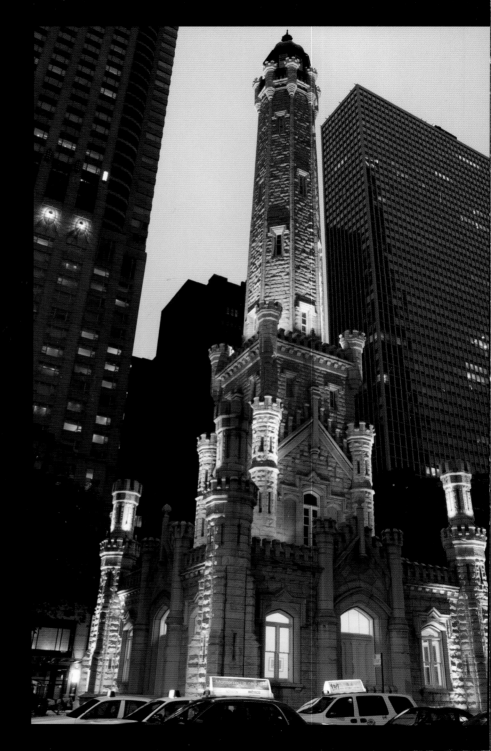